ROYAL COURT

The Royal Court Theatre presents

REMEMBRANCE DAY

by **Aleksey Scherbak**

translated by **Rory Mullarkey**

First performance at the Royal Court Jerwood Theatre Upstairs, Sloane Square,
London on Friday 18th March 2011

REMEMBRANCE DAY is presented as part of the International Playwrights Season:
A Genesis Foundation Project

REMEMBRANCE DAY

by **Aleksey Scherbak**

translated by **Rory Mullarkey**

in order of appearance
Boris **Luke Norris**
Anya **Ruby Bentall**
Sasha **Michael Nardone**
Lyosha **Iwan Rheon**
Sveta **Michelle Fairley**
Misha **Struan Rodger**
Valdis **Ewan Hooper**
Paulis **Sam Kelly**
Gint **Nick Court**

Director **Michael Longhurst**
Designer **Tom Scutt**
Lighting Designer **David Holmes**
Music & Sound Design **Ben & Max Ringham**
Casting Directors **Amy Ball & Julia Horan**
Assistant Director **Jacqui Honess-Martin**
Production Manager **Tariq Rifaat**
Fight Director **Bret Yount**
Stage Managers **Bonnie Morris, David Young**
Stage Management Work Placement **Jasmin McGarrell**
Costume Supervisor **Iona Kenrick**
Set Built by **Object Construction Ltd**
Set Painted by **Jodie Pritchard**

THE COMPANY

ALEKSEY SCHERBAK (Writer)

RECENT THEATRE INCLUDES: Halt (Slonim Drama Theatre, Belarus/Sakvoyah Theatre, Kiev/The Mikhail Chekhov Russian Drama Theatre, Riga/New Riga Theatre); Colonel Pilate (Dailes Theatre, Riga).

AWARDS INCLUDE: The Grand Prize in the Belarus Free Theatre's International Contemporary Drama Competition for Halt, the Russian "Honour, Duty and Virtue" prize for Colonel Pilate, the International Drama Competition at Badenweiler, Germany for Mister, the Russia-based Eurasia international drama competition for Colonel Pilate and the Strana screenplay competition for Halt and White Cloak.

Several of his plays have been presented at the Ljubimovka Drama Festival in Moscow, the Omsk International Drama Lab and the Prem'yera.txt festival. Aleksey represented the Baltic States in the Eurepica (New European Epic Challenge) project at the Belarus Free Theatre and Manteatern, Lund, Sweden in 2009 with his play, The Details of the Letter.

A number of his plays have been published in the Russian journal, Modern Drama, as well as other Russian and Belarusian play collections. He took part in the Royal Court Theatre's Moscow workshops in 2008 - 2009, where he developed Remembrance Day.

RUBY BENTALL (Anya)

THEATRE INCLUDES: Alice (Sheffield Crucible); The Miracle, DNA, Shoot/Get Treasure/Repeat (National).

TELEVISION INCLUDES: Lark Rise to Candleford, The Bill, New Tricks, Lost in Austen, Oliver Twist, Doctors, You Can Choose Your Friends, Holby City.

FILM INCLUDES: Robin Hood, The Courageous Heart of Irena Sendler, Tormented.

NICK COURT (Gint)

THEATRE INCLUDES: Macbeth (Shakespeare's Globe); The Giant (RSC/Hampstead); The Tempest, Anthony and Cleopatra, Julius Caesar (RSC); A Few Good Men (West End); Who's Afraid of Virginia Woolf? (Liverpool Playhouse); The Elephant Man (Sincera Productions).

FILM & TELEVISION INCLUDES: Injustice, Fish Without a Bicycle, The Shadow Line, Minder, The Bill, House of Saddam, Silent Witness, 55 Degrees North.

MICHELLE FAIRLEY (Sveta)

FOR THE ROYAL COURT: Loyal Women, The Weir (& West End & Broadway), Neverland, Oleanna (& West End).

OTHER THEATRE INCLUDES: Othello, The Wild Duck (Donmar); Dancing at Lughnasa (Old Vic); Scenes from the Big Picture (National); Gates of Gold (Trafalgar Studios); Midden (Hampstead); Don Juan (Manchester Royal Exchange); Greta Garbo Came to Donegal, The Hostage, Pentecost, Factory Girls (Tricycle); Paradise Lost/Woman of Troy/Love, Joyriders (Paines Plough); Macbeth (West Yorkshire Playhouse); The Doctors of Honour (Cheek by Jowl/tour); The Lady from the Sea (Citizens, Glasgow); Leonce and Lena (Sheffield Crucible); Dr Faustus, Philadelphia Here I Come (Tron, Glasgow); Shadow of a Gunman (Irish & US tours); Ashes to Ashes/Death and the Maiden (Lyric, Belfast).

TELEVISION INCLUDES: Game of Thrones, George Best, A Short Stay in Switzerland, Silent Witness, Midsomer Murders, Misfits, Lark Rise to Candleford, Taggart, Strictly Confidential, Trial and Retribution, The Catherine Tate Show, Bel's Boys, Golden Hour, Ahead of the Class, The Clinic, Holby City, Inspector Rebus, In Deep, McCready and Daughter, Births, Marriages and Deaths, Vicious Circle, Tom Jones, The Broker's Man, Precious Blood, Safe and Sound, A Mug's Game, Inspector Morse, Life after Life, Cardiac Arrest, Comics, The Long Roads, Force of Duty, Fleabites, Children of the North, Pentecost, Valentine Falls, Saracens, Hidden City, Cross Fire.

FILM INCLUDES: Chatroom, Harry Potter and the Deathly Hallows, The Duel, The Others, Hideous Kinky, A Soldier's Daughter Never Dies, Hidden Agenda.

DAVID HOLMES (Lighting Designer)

FOR THE ROYAL COURT: Alaska.

OTHER THEATRE INCLUDES: Cat on a Hot Tin Roof (Novello Theatre, London); The Gods Weep, Days of Significance (RSC); The Aliens, Cruising (Bush); Dick Whittington (Lyric Hammersmith); Victory: Choices in Reaction, The Road to Mecca (Arcola); The Chairs, Gagarin Way (Bath Theatre Royal); How to be an Other Woman, Things of Dry Hours (Gate); Goalmouth (The Sage, Gateshead); Ma Vie En Rose (Young Vic); Widowers' Houses, A Taste of Honey, See How They Run, Pretend You Have Big Buildings, Cyrano de Bergerac, Harvey and Roots (Manchester Royal Exchange); The Rise and Fall of Little Voice, Rope (Watermill Theatre, Newbury); Blood Wedding (South Bank); After Miss Julie, Othello, Woman In Mind and Be My Baby (Salisbury); TILT (Traverse); Hortensia and the Museum of Dreams (RADA); Humble Boy, The 101 Dalmatians (Northampton); Stallerhof (Southwark Playhouse); The Leningrad Siege (Wilton's Music Hall); The Trestle at Pope Lick Creek (Manchester Royal Exchange/Southwark Playhouse); The Fantasticks, Ain't Misbehavin'; House/Garden, Cleo, Camping, Emmanuelle and Dick (Harrogate); The Secret Rapture (Chichester); Twelfth Night (Cambridge); Look Back In Anger (Exeter); Dov and Ali, The Water Engine, The Water Harvest, Photos of Religion, A State of Innocence (Theatre503).

OPERA INCLUDES: Gurrelieder (Royal Festival Hall); La Serva Padrona, To Hell and Back (Opera Faber at the Viana do Castelo festival, Portugal); Rusalka (ETO); Sweetness and Badness (WNO).

DANCE INCLUDES: Fijis (for Jean Abreu Dance at the South Bank Centre/The Place); Inside (Jean Abreu Dance).

JACQUI HONESS MARTIN (Assistant Director)

DIRECTING INCLUDES: Auricular (Theatre503); Smith (British Museum); Antigone (Walworth Council Chambers); The Country (Goldsmiths College); An Experiment with an Air Pump (Drama Centre).

AS ASSISTANT DIRECTOR: Arcadia (West End); Woyzeck (Cardboard Citizens).

AS PLAYWRIGHT: Tell Out My Soul (Summer Plays Festival at the Public Theater New York).

EWAN HOOPER (Valdis)

FOR THE ROYAL COURT: The Weir, Toast, The Changing Room, The Kitchen, All Things Nice, Hammett's Apprentice, Bingo, Falkland Sound/Gibraltar Strait.

OTHER THEATRE INCLUDES: Stuff Happens, Roots (National); The Broken Heart, Coriolanus, Henry V, The Caretaker, Titus Andronicus (RSC); The Tempest, Mrs Warren's Profession, Much Ado About Nothing, Hindle Wakes, Richard II, The Recruiting Officer, The Doctor's Dilemma (Manchester Royal Exchange); Drummers, Blue Heart (Out of Joint); King Lear (Young Vic/International tour); Afore Night Come (Young Vic); The Bacchae (National Theatre of Scotland); A Woman in Black (West End).

TELEVISION INCLUDES: Across the Lake, Hunters Walk, In Denial of Murder, Heartbeat, Peak Practice, The Rules That Jack Made, No Hiding Place, The Avengers, King Lear.

FILM INCLUDES: Kinky Boots, Julius Caesar, How I Won the War, Dracula Has Risen from the Grave, Personal Services.

SAM KELLY (Paulis)

FOR THE ROYAL COURT: Under the Whaleback, Toast, This is a Chair, Killers.

OTHER THEATRE INCLUDES: When We Are Married, Wicked, The Female of the Species (West End); Kean (West End/tour); Dick Whittington (Barbican); Aladdin (Old Vic); A Funny Thing Happened on the Way to the Forum, The Homecoming, Pericles (National); HMS Pinafore (Savoy Theatre); Sunday Morning at the Centre of the World (Rosebriars Trust); Cinderella (Harlequin, Redhill); Cinderella (Swan West Wycombe); Wallflowering (Salisbury Playhouse); Le Bourgeois Gentilhomme (Edinburgh Festival); War & Peace (Shared Experience/National); Dead Funny (West End/tour); The Madras House (Royal Lyceum Edinburgh/Hammersmith Lyric); Last of the Red Hot Lovers (WYP).

TELEVISION INCLUDES: My Family, Magic Grandad, Heartbeat, Harvest, New Tricks, Christmas on the Riviera, The Bill, Where the Heart Is, Doctors, New Street Law, The Last Detective, Northern Lights, Midsomer Murders, Black Books, Casualty, Eastenders, Ashes to Ashes, Life Begins, Beauty, Ready When You Are Mr McGill, Micawber, Where There's Smoke, Monster TV, Oliver Twist, Peak Practice, Cold Feet, Magic With Everything, Holding On, 11 Men Against 11, Martin Chuzzlewitt, On the Up, Barbara, 'Allo 'Allo, Porridge, Grown Ups.

FILM INCLUDES: Nanny McPhee and the Big Bang, Honest, Topsy Turvy, Getaway, All or Nothing.

RADIO INCLUDES: Utz, The Good Soldier Schweik, Yesterday an Incident Occurred, Mum, Born for War, Keeping the Score, Yesterday, Far From Past It, Under The Loofah Tree, Silt.

MICHAEL LONGHURST (Director)

THEATRE INCLUDES: The Contingency Plan: On The Beach (Bush); Stovepipe (HighTide with National & Bush); dirty butterfly (Young Vic); 1 in 5 (Hampstead Theatre Daring Pairing); It's About Time (Nabokov/ Latitude Festival); This Wide Night (Bernie Grant Arts Centre); Ready (New Voices: 24 Hour Plays, Old Vic); Gaudeamus (Arcola); Guardians (Edinburgh Pleasance/Theatre503); Cargo (Edinburgh Pleasance/Oval House).

FOR THE ROYAL COURT, AS ASSISTANT DIRECTOR: The Family Plays.

OTHER THEATRE, AS ASSISTANT DIRECTOR: Arabian Nights (RSC); Gaslight (Old Vic); A Respectable Wedding (Young Vic).

AWARDS INCLUDE: 2007 Jerwood Directors Award for dirty butterfly; 2005 Fringe First for Guardians.

RORY MULLARKEY (Translator)

UPCOMING TRANSLATIONS FOR THE ROYAL COURT: Pagans (Internation Festival Reading).

AS A WRITER: Come To Where I'm From (Paines Plough/Royal Exchange).

Rory Mullarkey was on writing attachment to the Royal Court in March 2010 and was a member of the Royal Court's Studio Writers' Group in Summer 2010. He regularly works as a translator from Russian for the Royal Court Theatre International Department and the Belarus Free Theatre. He is currently under commission to Headlong Theatre and Pearson Playwright in Residence at the Royal Exchange Theatre.

MICHAEL NARDONE (Sasha)

THEATRE INCLUDES: Black Watch (National Theatre of Scotland World tour/Broadway); Laughing at the Fuhrer (Oran Mor); Peribanez (Young Vic); Gagarin Way (National/West End); Medea (Theatre Babel); Victoria (RSC); The Speculator, Knives in Hens (Bush); Widows, The Collection, Marisol, Europe, Buchanan, One Day All This Will Come to Nothing (Traverse); Sleeping Beauty (Dundee Rep); A Stranger Came Ashore, Merlin Part 1 & II, Mirandolina, The Marriage of Figaro, Shinda the Magic Ape, Wildman (Royal Lyceum, Edinburgh); Tales of the Arabian Nights, Cyrano de Bergerac, The Legend of Saint Julian (Communicado Theatre); Ane Satire of the Fourth Estate, The Cheviot, The Stag & The Black Black Oil (Wildcat Theatre); What Every Woman Knows (Watermill, Newbury); Tom Sawyer, Elidor (Contact Theatre, Manchester); Splatter (7.84 Theatre Co).

TELEVISION INCLUDES: Army Kids, The Castle, Taggart, Durham County, Ben Hur, Jinx, Doctors, Rockface, The Bill, Skins, Trial and Retribution, River City, Rome, Steel River Blues, Gunpowder Treason and Plot, Ultimate Force, Holby City, Rose and Maloney, Silent Witness, Inspector Rebus, Tinsel Town, The Creatives, Nature Boy, Life Support, Casualty, Wycliffe, Looking After Jo Jo, Ruth Rendell Mysteries, Take the High Road, Doctor Finlay, Low Winter Sun.

FILM INCLUDES: Being Human, Mercenaries, Intruders, Dot The I, The Match, Conquest of the South Pole, Soft Top Hard Shoulder, I Want to Be Like You, Forbidden Territory,

LUKE NORRIS (Boris)

THEATRE INCLUDES: The Habit of Art (National); The Gods Weep, Days of Significance (RSC); War Horse (National/West End); Shoot/Get Treasure/Repeat (Paines Plough); How to Disappear Completely and Never Be Found (Southwark Playhouse); White Boy (NWT at Soho)

TELEVISION INCLUDES: The Duchess, Skins, The Inbetweeners.

RADIO INCLUDES: Choice of Straws.

IWAN RHEON (Lyosha)

THEATRE INCLUDES: The Devil Inside Him (National Theatre of Wales); Spring Awakening (Lyric Hammersmith/West End); Eight Miles High (Royal Court, Liverpool); Moon Shadow (Drill Hall).

TELEVISION INCLUDES: Misfits, Secret Diary of a Call Girl, I Don't Care, Grandma's House, Pobol Y Cwm.

FILM INCLUDES: Resistance, Wild Bill.

AWARDS: Best Supporting Role in a Musical for Spring Awakening

BEN & MAX RINGHAM (Music & Sound Design)

FOR THE ROYAL COURT: The Author (& tour), The Pride.

OTHER THEATRE INCLUDES: Racing Demon (Sheffield Crucible); Les Parents Terrible (Donmar at Trafalgar Studios); Electric Hotel (Sadler's Wells/Fuel); Hamlet (Sheffield Crucible); Salome (Headlong); The Man From Stratford (Ambassadors); Polar Bears, Phaedra (Donmar); The Little Dog Laughed (Garrick); Three Days Of Rain (Apollo, West End); The Rise And Fall Of Little Voice (Vaudeville, West End); An Enemy Of The People (Sheffield Crucible); Really Old Like Forty Five (National); Piaf (Donmar/Vaudeville/Buenos Aires); Branded, All About My Mother (Old Vic); Contains Violence (Lyric Hammersmith); The Lover/The Collection (Comedy, West End); The Caretaker (Sheffield Crucible/Tricycle/tour); Amato Saltone, What If...?, Tropicana, Dance Bear Dance, The Ballad Of Bobby Francois (Shunt); The Pigeon (BAC); Henry IV Pts I & II (National).

AWARDS: Best Overall Achievement in an Affiliate Theatre Olivier award for The Pride.

Ben and Max are associate artists with the Shunt collective and two thirds of the band Superthriller.

STRUAN RODGER (Uncle Misha)

FOR THE ROYAL COURT: Within Two Shadows, The Removalists, A Pagan Place, Lear.

OTHER THEATRE INCLUDES: Julius Caesar (Barbican/Paris/Madrid/Luxembourg); Medea (West End/BAM, New York/tour & Broadway); Waiting for Godot (West End); Richard II (National/Paris/Salzburg Festival); The Moonstone, A Doll's House (Manchester Royal Exchange); Sienna Red (UK tour); The Crucible (Leicester Haymarket); 'Tis Pity She's A Whore, Tales from the Vienna, Tamburlaine the Great, Hamlet, Engaged (National); The Deliberate Death of a Polish Priest (Almeida); Progress (Lyric Hammersmith/Bush); Shadow of a Gunman (Nottingham Playhouse); Troilus & Cressida (Young Vic); The Bacchae (Prospect tour); The Speakers (Joint Stock).

TELEVISION INCLUDES: Law & Order, The Thick of It, The Bill, Moses Jones, Midsomer Murders, Taggart, Distant Shores, Grease Monkeys, Sea of Souls, A Case of Evil, The Waiting Time, The Vice, An Unsuitable Job for a Woman, Richard II, Mirad: A Boy from Bosnia, Moll Flanders, Highlander, Lovejoy, Faith, Circle of Deceit, Chandler & Co, Prime Suspect, Spender, Maigret, Moon & Son, A Woman at War, Blood Rights, Christopher Columbus, Poirot, Come Home Charlie, Face Them, Bergerac, Game Set and Match, Lost Belongings, The Deliberate Death of a Polish Priest, The Detective, Edge of Darkness, Boys from the Blackstuff, A Captain's Tale, Life After Death, Sweet Nothings, Rumpole of the Bailey, The Mayor of Casterbridge, The Love School, The Lonely Man's Lover.

FILM INCLUDES: 7 Lives, Kill List, Stardust, Young Adam, The Innocent Sleep, The Madness of King George, Four Weddings and a Funeral, A Child from the South, Afraid of the Dark, Dark Obsessions, Reunion, Hitler: A Portrait of Evil, The Manions of America, Chariots of Fire, Les Miserables, Too Many Chefs.

TOM SCUTT (Designer)

THEATRE INCLUDES: Romeo and Juliet (RSC); Hamlet (Sheffield Crucible); Through A Glass Darkly (Almeida); Mogadishu (Royal Exchange, Manchester/Lyric Hammersmith); After Miss Julie (Salisbury Playhouse); Here Lies Mary Spindler (RSC at Latitude Festival); Pressure Drop (On Theatre/ Wellcome Collection); Dick Whittington, Jack and The Beanstalk (Lyric Hammersmith); The Contingency Plan: On the Beach, Resilience (Bush); A Midsummer Night's Dream, Edward Gant's Amazing Feats of Loneliness (Headlong); Vanya, Unbroken, The Internationalist (Gate); Bay (Young Vic); The Merchant of Venice; Metropolis (Theatre Royal Bath); The Observer (design consultant, National Theatre Studio); Paradise Lost (Southwark Playhouse); Mad Funny, Just, The Water Harvest (Theatre503); Return (Watford); The Comedy of Errors (RWCMD/RSC); Skellig (onO Productions); Loaded (Fireraisers Theatre); Branwen (North Wales Stage); Dog Tags (European Live Arts Network).

AWARDS INCLUDE: 2007 Linbury Biennial Prize and the Jocelyn Herbert Award for Stage Design for his work with Headlong Theatre.

THE ENGLISH STAGE COMPANY
AT THE ROYAL COURT THEATRE

*'For me the theatre is really a religion or way of life.
You must decide what you feel the world is about
and what you want to say about it, so that everything
in the theatre you work in is saying the same thing
… A theatre must have a recognisable attitude. It will
have one, whether you like it or not.'*

George Devine, first artistic director of the
English Stage Company: notes for an unwritten
book.

photo: Stephen Cummiskey

As Britain's leading national company dedicated to new work, the Royal Court Theatre produces
new plays of the highest quality, working with writers from all backgrounds, and asking questions
about who we are and the world in which we live.

"The Royal Court has been at the centre of British cultural life for the past 50 years, an engine
room for new writing and constantly transforming the theatrical culture." Stephen Daldry

Since its foundation in 1956, the Royal Court has presented premieres by almost every leading
contemporary British playwright, from John Osborne's Look Back in Anger to Caryl Churchill's
A Number and Tom Stoppard's Rock 'n' Roll. Just some of the other writers to have chosen the
Royal Court to premiere their work include Edward Albee, John Arden, Richard Bean, Samuel
Beckett, Edward Bond, Leo Butler, Jez Butterworth, Martin Crimp, Ariel Dorfman, Stella Feehily,
Christopher Hampton, David Hare, Eugène Ionesco, Ann Jellicoe, Terry Johnson, Sarah Kane, David
Mamet, Martin McDonagh, Conor McPherson, Joe Penhall, Lucy Prebble, Mark Ravenhill, Simon
Stephens, Wole Soyinka, Polly Stenham, David Storey, Debbie Tucker Green, Arnold Wesker and
Roy Williams.

"It is risky to miss a production there." Financial Times

In addition to its full-scale productions, the Royal Court also facilitates international work at a
grass roots level, developing exchanges which bring young writers to Britain and sending British
writers, actors and directors to work with artists around the world. The research and play
development arm of the Royal Court Theatre, The Studio, finds the most exciting and diverse
range of new voices in the UK. The Studio runs playwriting groups including the Young Writers
Programme, Critical Mass for black, Asian and minority ethnic writers and the biennial Young
Writers Festival. For further information, go to www.royalcourttheatre.com/playwriting/the-
studio.

"Yes, the Royal Court is on a roll. Yes, Dominic Cooke has just the genius and kick that this venue
needs… It's fist-bitingly exciting." Independent

INTERNATIONAL PLAYWRIGHTS AT THE ROYAL COURT

Since 1992 the Royal Court has placed a renewed emphasis on the development of international work and a creative dialogue now exists with theatre practitioners all over the world including Brazil, Cuba, France, Germany, India, Mexico, Nigeria, Palestine, Romania, Russia, Spain and Syria, and with writers from seven countries from the Near East and North Africa region. All of these development projects are supported by the Genesis Foundation and the British Council.

The Royal Court has produced new International plays through this programme since 1997, most recently Our Private Life by Pedro Miguel Rozo (Colombia) in 2011, Disconnect by Anupama Chandrasekhar (India) in 2010, The Stone by Marius von Mayenburg (Germnay) in 2009 and Bliss by Olivier Choinière (Quebec) in 2008. In 2007, the Royal Court presented a season of five new international plays – The Ugly One by Marius von Mayenburg (Germany), Kebab by Gianina Carbunariu (Romania), Free Outgoing by Anupama Chandrasekhar, and a double bill of The Good Family by Joakim Pirinen (Sweden) and The Khomenko Family Chronicles by Natalia Vorozhbit (Ukraine). Other recent work includes On Insomnia and Midnight by Edgar Chías (Mexico), My Name is Rachel Corrie, edited from the writings of Rachel Corrie by Alan Rickman and Katharine Viner, Way to Heaven by Juan Mayorga (Spain), Amid the Clouds by Amir Reza Koohestani (Iran), and At the Table and Almost Nothing by Marcos Barbosa (Brazil).

THE ROYAL COURT THEATRE AND NEW WRITING IN RUSSIAN

Since 1999 the Royal Court has been working with Russian-language playwrights who have been in the vanguard of a major revival in contemporary playwriting across the Russian-speaking world. This work began in 1999, when then-Literary Manager, Graham Whybrow took part in the first seminar on new writing, organised by the British Council Moscow and the Golden Mask Theatre Festival. This led to one of the projects developed, Moscow Open City, being performed in Moscow and as part of the International Playwrights Season 2000. Further workshops have taken place in Moscow, and in December 2000 work started with Siberian writers at the Globus Theatre, Novosibirsk. The Royal Court was instrumental in starting a new movement influenced by verbatim theatre to tackle a range of Russian political and domestic issues. This work began in 2000, led by Stephen Daldry, James Macdonald and Elyse Dodgson. More work took place in Moscow and Novosibirsk in spring 2003, continuing through 2004 in Moscow, including writers from Ukraine. In addition, since 2003 five Russian playwrights and two Ukrainian playwrights have participated in the International Residency for Emerging Playwrights in London.

In May 2001 the Royal Court presented a week of readings, New Plays from Russia, during which four playwrights worked in London with British actors and directors. This was the first opportunity for a UK audience to see work emerging from post-perestroika Russia, and included a reading of Vassily Sigarev's Plasticine and three other plays. Plasticine went on to be produced as part of the 2002 International Playwrights Season, winning the Evening Standard's Charles Wintour Award for Most Promising New Playwright. The theatre has since produced Sigarev's Black Milk (2003) and Ladybird (2004), as well as the Presnyakov Brothers' Terrorism (March 2003) and Playing the Victim (August/September 2003) in a co-production with Told by an Idiot. The 2007 International Playwrights Season featured The Khomenko Family Chronicles by Ukrainian playwright Natalia Vorozhbit.

The latest project started in December 2008, when Elyse Dodgson and playwright Mike Bartlett returned to Moscow to start work with a group of playwrights from all over Russia as well as Belarus, Latvia and Uzbekistan. This project continued over 18 months, in partnership with the Lubimovka Festival of New Writing, with Royal Court Artistic Director, Dominic Cooke joining the team. Aleksey Scherbak took part in this group, as did Pavel Pryazhko (Belarus), whose play The Harvest will be presented as rehearsed reading as part of this International Playwrights Season. There will also be a reading of Pagans by Ukrainian playwright Anna Yablonskaya who took part in the 2010 International Residency.

The Genesis Foundation supports the Royal Court Theatre's International Playwrights Programme. To find and develop the next generation of professional playwrights, the Foundation funds workshops in diverse countries as well as residencies at the Royal Court. The Foundation's involvement extends to productions and rehearsed readings. The Genesis Foundation helps the Royal Court offer a springboard for young writers to greater public and critical attention. For more information, please visit www.genesisfoundation.org.uk

REMEMBRANCE DAY is presented as part of the International Playwrights Season, A Genesis Foundation Project, and produced by the Royal Court's International Department:

Associate Director **Elyse Dodgson**
International Projects Manager **Chris James**
International Assistant **William Drew**

MAKING IT HAPPEN

The Royal Court develops and produces more new plays than any other national theatre in the UK. To produce such a broad and eclectic programme and all of our play development activities costs over £5 million every year. Just under half of this is met by principal funding from Arts Council England. The rest must be found from box office income, trading and financial support from private individuals, companies and charitable foundations. The Royal Court is a registered charity (231242) and grateful for every donation it receives towards its work.

You can support the theatre by joining one of its membership schemes or by making a donation towards the Writers Development Fund. The Fund underpins all of the work that the Royal Court undertakes with new and emerging playwrights across the globe, giving them the tools and opportunities to flourish.

To find out how to become involved with the Royal Court and the difference that your support could make visit www.royalcourttheatre.com/support-us or call the Development Office on 020 7565 5049.

MAJOR PARTNERSHIPS

The Royal Court is able to offer its unique playwriting and audience development programmes because of significant and longstanding partnerships with the organisations that support it.

Principal funding is received from Arts Council England. The Genesis Foundation supports the Royal Court's work with International Playwrights. Theatre Local is sponsored by Bloomberg. The Jerwood Charitable Foundation supports new plays by playwrights through the Jerwood New Playwrights series. The Artistic Director's Chair is supported by a lead grant from The Peter Jay Sharp Foundation, contributing to the activities of the Artistic Director's office. Over the past ten years the BBC has supported the Gerald Chapman Fund for directors.

DEVELOPMENT ADVOCATES

John Ayton
Elizabeth Bandeen
Tim Blythe
Anthony Burton
Sindy Caplan
Cas Donald (Vice Chair)
Allie Esiri
Celeste Fenichel
Anoushka Healy
Emma Marsh (Chair)
Mark Robinson
William Russell
Deborah Shaw Marquardt (Vice Chair)
Nick Wheeler
Daniel Winterfeldt

Supported by
**ARTS COUNCIL
ENGLAND**

PROGRAMME SUPPORTERS

PUBLIC FUNDING
Arts Council England, London
British Council
European Commission
Representation in the UK

CHARITABLE DONATIONS
American Friends of the Royal Court
Martin Bowley Charitable Trust
The Brim Foundation*
Gerald Chapman Fund
City Bridge Trust
Cowley Charitable Trust
The H and G de Freitas Charitable Trust
The Edmond de Rothschild Foundation*
Do Well Foundation Ltd*
The Dorset Foundation
The John Ellerman Foundation
The Epstein Parton Foundation*
The Eranda Foundation
Genesis Foundation
J Paul Getty Jnr Charitable Trust
The Golden Bottle Trust
The Goldsmiths' Company
The Haberdashers' Company
Paul Hamlyn Foundation
Jerwood Charitable Foundation
Marina Kleinwort Charitable Trust
The Leathersellers' Company
Frederick Loewe Foundation*
John Lyon's Charity
The Andrew W Mellon Foundation
The Laura Pels* Foundation*
Jerome Robbins Foundation*
Rose Foundation
Royal Victoria Hall Foundation
The Peter Jay Sharp Foundation*
The Steel Charitable Trust
John Thaw Foundation
The Garfield Weston Foundation

CORPORATE SUPPORTERS & SPONSORS
BBC
Bloomberg
Coutts & Co
Ecosse Films
French Wines
Grey London
Kudos Film & Television
MAC
Moët & Chandon
Oakley Capital Limited
Smythson of Bond Street

BUSINESS ASSOCIATES, MEMBERS & BENEFACTORS
Auerbach & Steele Opticians
Bank of America Merrill Lynch
Hugo Boss
Lazard
Louis Vuitton
Oberon Books
Savills
Vanity Fair

INDIVIDUAL MEMBERS

ICE-BREAKERS
Anonymous
Rosemary Alexander
Lisa & Andrew Barnett
Mrs Renate Blackwood
Ossi & Paul Burger
Mrs Helena Butler
Mr Claes Hesselgren & Mrs Jane Collins
Mark & Tobey Dichter
Ms P Dolphin
Elizabeth & James Downing
Virginia Finegold
Charlotte & Nick Fraser
Alistair & Lynwen Gibbons
Mark & Rebecca Goldbart
Mr & Mrs Green
Sebastian & Rachel Grigg
Mrs Hattrell
Steven & Candice Hurwitz
Mrs R Jay
David Lanch
Yasmine Lever
Colette & Peter Levy
Watcyn Lewis
Mr & Mrs Peter Lord
David Marks QC
Nicola McFarland
Jonathan & Edward Mills
Ann Norman-Butler
Emma O'Donoghue
Georgia Oetker
Michael & Janet Orr
Mr & Mrs William Poeton
Really Useful Theatres
Mr & Mrs Tim Reid
Mrs Lois Sieff OBE
Nick & Louise Steidl
Torsten Thiele
Laura & Stephen Zimmerman

GROUND-BREAKERS
Anonymous
Moira Andreae
Nick Archdale
Charlotte Asprey
Jane Attias*
Caroline Baker
Brian Balfour-Oatts
Elizabeth & Adam Bandeen
Ray Barrell
Dr Kate Best
Mr & Mrs Philip Blackwell
Stan & Val Bond

Neil & Sarah Brener
Miss Deborah Brett
Sindy & Jonathan Caplan
Gavin & Lesley Casey
Sarah & Philippe Chappatte
Tim & Caroline Clark
Carole & Neville Conrad
Kay Ellen Consolver & John Storkerson
Clyde Cooper
Ian & Caroline Cormack
Mr & Mrs Cross
Andrew & Amanda Cryer
Alison Davies
Noel De Keyzer
Polly Devlin OBE
Rob & Cherry Dickins
Denise & Randolph Dumas
Robyn Durie
Glenn & Phyllida Earle
Allie Esiri
Margaret Exley CBE
Celeste & Peter Fenichel
Margy Fenwick
Tim Fosberry
The Edwin Fox Foundation
The Ury Trust
John Garfield
Beverley Gee
Mr & Mrs Georgiades
Nick & Julie Gould
Lord & Lady Grabiner
Richard & Marcia Grand*
Nick Gray
Reade & Elizabeth Griffith
Don & Sue Guiney
Jill Hackel & Andrzej Zarzycki
Mary & Douglas Hampson
Sally Hampton
Sam & Caroline Haubold
Anoushka Healy
Mr & Mrs Johnny Hewett
Gordon Holmes
The David Hyman Charitable Trust
Mrs Madeleine Inkin
Nicholas Jones
Nicholas Josefowitz
Dr Evi Kaplanis
David P Kaskel & Christopher A Teano
Vincent & Amanda Keaveny
Peter & Maria Kellner*
Philip & Joan Kingsley
Mr & Mrs Pawel Kisielewski
Maria Lam
Larry & Peggy Levy
Daisy & Richard Littler
Kathryn Ludlow
David & Elizabeth Miles
Barbara Minto
Ann & Gavin Neath CBE
Murray North
Clive & Annie Norton
William Plapinger & Cassie Murray*

Andrea & Hilary Ponti
Wendy & Philip Press
Serena Prest
Julie Ritter
Mark & Tricia Robinson
Paul & Gill Robinson
Paul & Jill Ruddock
William & Hilary Russell
Julie & Bill Ryan
Sally & Anthony Salz
Bhags Sharma
Mrs Doris Sherwood
The Michael and Melanie Sherwood Charitable Foundation
Tom Siebens & Mimi Parsons
Richard Simpson
Anthony Simpson & Susan Boster
Samantha & Darren Smith
Brian Smith
Sandi Ulrich
Amanda Vail
Matthew & Sian Westerman
Mr & Mrs Nick Wheeler
Carol Woolton
Katherine & Michael Yates*

BOUNDARY-BREAKERS
Katie Bradford
Lydia & Manfred Gorvy
Ms Alex Joffe
Steve Kingshott
Emma Marsh

MOVER-SHAKERS
Anonymous
Mr & Mrs Ayton
Cas Donald
Lloyd & Sarah Dorfman
Duncan Matthews QC
Ian & Carol Sellars
Edgar and Judith Wallner

HISTORY-MAKERS
Eric Abraham & Sigrid Rausing
Miles Morland

MAJOR DONORS
Rob & Siri Cope
Daniel & Joanna Friel
Jack & Linda Keenan*
Deborah & Stephen Marquardt
The David & Elaine Potter Foundation
Lady Sainsbury of Turville
NoraLee & Jon Sedmak*
Jan & Michael Topham
The Williams Charitable Trust

*Supporters of the American Friends of the Royal Court (AFRCT)

FOR THE ROYAL COURT

Royal Court Theatre, Sloane Square, London SW1W 8AS
Tel: 020 7565 5050 Fax: 020 7565 5001
info@royalcourttheatre.com, www.royalcourttheatre.com

Artistic Director **Dominic Cooke**
Deputy Artistic Director **Jeremy Herrin**
Associate Director **Sacha Wares***
Artistic Associate **Emily McLaughlin***
Diversity Associate **Ola Animashawun***
Education Associate **Lynne Gagliano***
Producer **Vanessa Stone***
Trainee Director **Monique Sterling‡**
PA to the Artistic Director **Pamela Wilson**

Literary Manager **Christopher Campbell**
Senior Reader **Nicola Wass*****
Literary Assistant **Marcelo Dos Santos**
Studio Administrator **Clare McQuillan**
Writers' Tutor **Leo Butler***
Pearson Playwright **DC Moore** ^

Associate Director International **Elyse Dodgson**
International Projects Manager **Chris James**
International Assistant **William Drew**

Casting Director **Amy Ball**
Casting Assistant **Lotte Hines**

Head of Production **Paul Handley**
JTU Production Manager **Tariq Rifaat**
Production Administrator **Sarah Davies**
Head of Lighting **Matt Drury**
Lighting Deputy **Stephen Andrews**
Lighting Assistants **Katie Pitt, Jack Williams**
Lighting Board Operator **Jack Champion**
Head of Stage **Steven Stickler**
Stage Deputy **Dan Lockett**
Stage Chargehand **Lee Crimmen**
Chargehand Carpenter **Richard Martin**
Head of Sound **David McSeveney**
Sound Deputy **Alex Caplen**
Sound Operator **Sam Charleston**
Head of Costume **Iona Kenrick**
Costume Deputy **Jackie Orton**
Wardrobe Assistant **Pam Anson**

Executive Director **Kate Horton**
Head of Finance & Administration **Helen Perryer**
Senior Finance & Administration Officer
Martin Wheeler
Finance Officer **Rachel Harrison***
Finance & Administration Assistant **Tessa Rivers**
Administrative Assistant **Holly Handel**
Production Assistant **David Nock**

Acting Head of Marketing & Sales **Becky Wootton**
Press & Public Relations Officer **Anna Evans**
Communications Assistant **Ruth Hawkins**
Communications Interns **Meera Shehar, Daisy Woodward**

Sales Manager **Kevin West**
Box Office Sales Assistants **Cheryl Gallagher, Stephen Laughton, Helen Murray*, Ciara O'Toole, Natalie Tarjanyi*, Amanda Wilkin***

Head of Development **Gaby Styles**
Senior Development Manager **Hannah Clifford**
Development Manager **Lucy Buxton**
Development Assistants **Anna Clark, Penny Saward**

Theatre Manager **Bobbie Stokes**
Deputy Theatre Manager **Daniel O'Neill**
Duty Managers **Fiona Clift*, Siobhan Lightfoot ***
Events Manager **Joanna Ostrom**
Bar & Food Manager **Sami Rifaat**
Bar & Food Assistant Managers **Ali Christian, Becca Walton**
Head Chef **Charlie Brookman**
Sous Chef **Paulino Chuitcheu**
Bookshop Manager **Simon David**
Assistant Bookshop Manager **Edin Suljic***
Bookshop Assistant **Vanessa Hammick ***
Customer Service Assistant **Deirdre Lennon***
Stage Door/Reception **Simon David*, Paul Lovegrove, Tyrone Lucas**

Thanks to all of our box office assistants, ushers and bar staff.

^This theatre has the support of the Pearson Playwrights' Scheme sponsored by the Peggy Ramsa Foundationy

** The post of Senior Reader is supported by NoraLee & Jon Sedmak through the American Friends of the Royal Court Theatre.

‡The post of the Trainee Director is supported by the BBC writersroom.

* Part-time.

ENGLISH STAGE COMPANY

President
Dame Joan Plowright CBE

Honorary Council
Sir Richard Eyre CBE
Alan Grieve CBE
Martin Paisner CBE

Council
Chairman **Anthony Burton**
Vice Chairman **Graham Devlin CBE**

Members
Jennette Arnold OBE
Judy Daish
Sir David Green KCMG
Joyce Hytner OBE
Stephen Jeffreys
Wasfi Kani OBE
Phyllida Lloyd CBE
James Midgley
Sophie Okonedo OBE
Alan Rickman
Anita Scott
Katharine Viner
Stewart Wood

REMEMBRANCE DAY

Aleksey Scherbak

REMEMBRANCE DAY

Translated by Rory Mullarkey

OBERON BOOKS
LONDON

WWW.OBERONBOOKS.COM

First published in 2011 by Oberon Books Ltd
521 Caledonian Road, London N7 9RH
Tel: +44 (0) 20 7607 3637 / Fax: +44 (0) 20 7607 3629
e-mail: info@oberonbooks.com
www.oberonbooks.com

A catalogue record for this book is available from the British Library.

ISBN: 978-1-84943-105-7

Cover image by Patrick Morgan

Printed in Great Britain by CPI Antony Rowe, Chippenham.

Characters

SASHA – a man, around 40

SVETA – his wife

LYOSHA – his son, in his first year of university

ANYA – his daughter, in her final year of school

VALDIS – his neighbour, an elderly man

PAULIS – a friend of Valdis, an elderly man

UNCLE MISHA – a Soviet Army veteran, an elderly man

GINT – a Latvian political activist

BORIS – a Russian political activist

GLOSSARY

Latvia A small country on the Baltic Sea. Member of the European Union. In the streets of its towns there is no variety in skin colour. Everyone is white. However, almost half the population is made up of members of Russian-speaking denominations, descendants of immigrants from across the former Soviet Union – Russians, Ukrainians, Belarusians. Members of the indigenous population are known as Latvians.

Legionaries Ethnic Latvians, veterans of the Latvian Legion of the Waffen SS, which fought as part of Hitler's army in the Second World War.

16th March Latvian Legion Day. The anniversary of the first occasion on which both divisions of the Latvian Legion fought side-by-side. It is commemorated in Latvia as a day of remembrance.

SCENE 1

15th March, evening. A hallway in a standard block of flats. Three doors into different apartments. A girl and a young man are in the hallway. The man is standing a few steps down the staircase, leaning against the banister.

BORIS: Look, tomorrow isn't about getting on TV or getting in the papers. No, I'm not bothered about that. Anya, tomorrow isn't about heroics. It's about those Nazis seeing us Russians.

ANYA: I'm a bit scared, to be honest. It's my first time…

BORIS: Don't worry, you won't be there on your own, and anyway… I'll be there. Wrap up warm. A couple of years back, maybe three, I got so cold, a reporter was asking me questions and I couldn't even answer my teeth were chattering so much.

ANYA: I'll wrap up warm. What should I write on my banner?

BORIS: Decide for yourself. Or ask your neighbour. *(Points at the right-hand door.)*

ANYA: Uncle Misha?

BORIS: That old man slotted so many Germans during the War! I used to see him a lot when I first started. When young blokes joined the party they'd get given five veterans each. This was a while ago, now. You'd help them out, bring them things… even just go have a chat with them. They enjoy it. Now I only pop round on the ninth of May. Bring him some presents. Have you seen those medals of his?

ANYA: Yeah. So have you already got some banners ready?

BORIS: Yeah, of course. "Sixteenth of March: Day of Disgrace!" "We beat you then and we'll beat you now!" "Legionaries: The soldiers of Hitler!" Loads of different ones.

ANYA: And what's gonna be on yours?

BORIS: "The Latvian SS Legion: Time won't wash off the blood!"

ANYA: Powerful… Is there any chance I could have one of the ones you've already made?

BORIS: Problem at home?

ANYA: No, no problems… Just, they don't know I'm going. My dad thinks all politicians are bribe-taking liars.

BORIS: Anya I don't take bribes. Why would anyone bribe me? You should talk to him about our party.

ANYA: I've already tried. Not about the party, but about some of the ideas. He just tells me to get on with my homework.

BORIS: Well you'll never change society if you can't change your own family. Talk to him today. Make him listen to you. You know, you're old enough to have your own views… At your age people are already having babies.

A man of around forty ascends the staircase. The conversation breaks off. The man looks at BORIS.

ANYA: Hi Dad.

BORIS: Hello.

ANYA: This is Boris, Dad.

The men look at one another.

SASHA: Sasha. So you were saying something about having babies.

ANYA: That wasn't what we were talking about, Dad.

SASHA: Then what were you talking about?

ANYA: Nothing.

BORIS: We were looking for a way out of an awkward situation.

SASHA: Then come inside, you can look for it there.

BORIS: I'm off I'm afraid. *(To ANYA.)* Write something about fascism.

ANYA: Okay.

BORIS: *(To SASHA.)* Goodbye. *(To ANYA.)* See you tomorrow.

BORIS leaves. SASHA and ANYA go into the flat. They start taking off their coats. A young man comes to meet them.

LYOSHA: Dad… *(To ANYA.)* Hey sis. Dad, is there any chance of getting some extra English lessons…

SASHA: Wait. *(To ANYA, nodding at the door.)* Who was that?

ANYA: Boris.

SASHA: Yeah, I got that.

They all go into the main room.

LYOSHA: So what's the deal with my English then?

SASHA: I told you Lyosha, wait. We'll sort out your English later. *(To ANYA.)* He your boyfriend?

ANYA: I don't have a boyfriend. I don't have time.

LYOSHA: Maybe it's time you got one…

SASHA: So why are you seeing him tomorrow then?

ANYA: It's the Legionaries' parade tomorrow. I need to make a banner and he was helping me think of a slogan. He was just walking me home. He's the leader of the party's youth wing. He knows Uncle Misha.

SASHA: What party? What banner? What's all this got to do with Uncle Misha?

LYOSHA: Let me just quickly explain it to you, then we can talk about my English…

SASHA: Well explain then.

LYOSHA: While you're out at work safeguarding the welfare of our family, your daughter has joined the political struggle.

She's joined the Russian party, she goes to meetings and stuff like that.

SASHA: And your studies?

ANYA: I'm still studying.

LYOSHA: She's getting everything done. So yeah. Tomorrow's Legionaries' Day…

SASHA: I know. But what's that got to do with Anya?

LYOSHA: That's what I'm saying, she probably wants to protest.

The sound of the front door opening.

LYOSHA: *(To ANYA.)* Right?

ANYA nods. A woman enters the room.

LYOSHA: Hi Mum.

SASHA: Sveta, did you know about this party of Anya's?

SVETA: Yeah.

SASHA: And did you know about tomorrow?

SVETA: She said there was some kind of meeting.

SASHA: Not a meeting, a parade. The Latvian veterans are going out to march and your daughter's demonstrating against them. *(To ANYA.)* Overall… I'm against it.

ANYA: You're right. It's better just to do nothing.

SASHA: You'll do what I decide.

ANYA: You can't forbid me!

SASHA: Why not?

LYOSHA: Let's just not get into an argument…

SVETA: Anya, do you absolutely have to be there?

SASHA: I can forbid you if I like, whilst you're living under my roof.

ANYA: Am I not allowed my own views?

SVETA: *(To SASHA.)* Did you buy Uncle Misha his newspaper?

SASHA: Yeah. It's in the hall.

SVETA: Anya, go take it through to him.

ANYA gets up, and leaves.

LYOSHA: Dad can we talk about my English now? It's three hundred euros. Extra lessons…

SCENE 2

UNCLE MISHA's flat. The old man is sitting on his bed. Coughing. ANYA is standing next to the bed. The newspaper is on the table.

MISHA: I haven't seen you in a while.

ANYA: I've got a lot on. Exams soon. Extra lessons. Chemistry, biology…

MISHA: I never got to finish school. The War got in the way. Stiff competition, getting into medical school. You think you'll make it?

ANYA: I'll try my best.

MISHA: You can practice on me.

ANYA: I want to be a surgeon… You're not my kind of patient.

MISHA: Well yes, yes… *(He coughs.)* I'd be straight to intensive care. Either that or to the psychiatrist. How's your father?

ANYA: Fine.

MISHA: A surgeon, eh… That's quite a job. You're not scared of blood, are you?

ANYA: No.

MISHA: There was this young female doctor posted out to us at the front. Fainted at her first glimpse of blood. It was terrible. Kept fainting for two weeks, so they sent her

back to HQ. A month later she married the company commander.

ANYA: I'm not going to faint. I know how to do loads already.

MISHA: Well let's hope so. *(He stands.)* Let's go for a walk. Just for half an hour or so. I haven't been outside for ages.

ANYA: I'm supposed to go and make a banner… It's the sixteenth of March tomorrow. Legionaries' Day.

MISHA: The sixteenth already?

ANYA: The party's going to protest. I just still haven't come up with a slogan.

MISHA: How about: "Die, you dogs!" Or would that not be allowed? *(Pause.)* We liberated this one village during the final advance. There was a naked woman dancing in the street, singing songs. The Nazis had killed her four children. The oldest was six, the youngest six months. She'd gone out of her mind. You see something like that you remember it for the rest of your life. *(Pause.)* Make them sit at home, they shouldn't be allowed to clog up our streets with their marching. On those very streets we fought against them. The Germans had already surrendered but none of this lot had. And nowadays you can't tell which ones are still fascists and which ones aren't, since they're all dressed up in the same uniform. *(MISHA starts to cough heavily. He sits down.)*

ANYA runs to fetch some water. She brings it over. UNCLE MISHA drinks it.

Ugh. This cough'll be the death of me. I never thought old age would make me a child in someone else's family.

ANYA: Dad wants me to stay at home.

MISHA: Why?

ANYA: He just does! He basically never speaks to me. I can't even remember the last time he did. And today he suddenly starts dictating what I should do.

MISHA: And what do you think?

ANYA: I tried to explain to him...

MISHA: So you're not going?

ANYA: I don't know. Probably not.

MISHA: Turn back the clock thirty years, I'd be there. I'd have shown them! *(He coughs.)*

ANYA: You mustn't get worked up. Do you want me to check your blood pressure?

MISHA: Time was I'd go around the schools, telling my story, giving speeches, the kids'd give me flowers. There was this one schoolmistress, back when I was young, about your father's age, she fell in love with me. She told me there weren't any real heroes any more. She loved me for my medals.

ANYA: And did you love her?

MISHA: I was already married by then.

ANYA: I can't remember your wife.

MISHA: You were five when she passed away. Then my daughter left. They took away her husband's flat.

ANYA: And gave it back to a Latvian?

MISHA: Yes, to someone who'd run away to Germany under Hitler. I told her to stay. But she didn't listen to me. And she was right not to listen. She left for Moscow... Now we only talk on the phone... She sent me a photograph, recently... *(Pause.)* I sit there looking at it and I just boil up inside.

ANYA: You should have gone with them, Uncle Misha. In Russia Soviet veterans get honour and respect. But here...

MISHA: Why should I leave? I freed this city from the Nazis. I was wounded three times. I've lived here nearly my whole life. My comrades are buried here. My wife is buried here.

I'm not used to running away, Anya. Men shouldn't just run away.

ANYA: I just can't imagine how offended you must be, watching all this.

MISHA: Oh, to Hell with them. Let them play at their Independence. Let them think they're standing on their own two feet. The only offensive thing is that no one stands up for us. But it doesn't matter, I'll put up with it. I don't have long left…

ANYA: Don't talk like that, Uncle Misha.

MISHA: Five years ago, Anya, on the tram… this old Latvian woman, I bumped into her by accident… She started screaming her head off. Russian pig! I came home and packed a suitcase. That's it, I thought, it's time. I sat down, drank a glass of vodka. And stayed. Maybe she was ill? No one's ever come into my flat and said: go back to your Russia.

UNCLE MISHA goes to the wardrobe and takes out a long, heavy package.

And if they do come… Take a look at this *(Unwrapping the package).* My rifle. Just don't tell anyone. At the end of the War I was awarded this. My name's engraved on it. If this lot found out about it they'd take it off me.

ANYA: I won't tell anyone.

UNCLE MISHA tenderly strokes the rifle. Loads a round into it, then takes the round out. ANYA watches.

MISHA: Generals were awarded pistols but snipers, and not all of them, mind, were given rifles… Just let them try me! I'd give them a little reminder of Stalingrad!

UNCLE MISHA starts to cough heavily. ANYA helps him to lie down.

ANYA: *(Helping MISHA.)* Lie down, lie down, Uncle Misha. Rest yourself. I'm going tomorrow. I'm definitely going.

MISHA: You know, for us snipers, Anya, it wasn't about who was the best shot, we were all good shots, it was about who was the most cunning, the most patient...

SCENE 3

SASHA, SVETA and LYOSHA are in their flat. Their conversation continues.

SASHA: *(To SVETA.)* I get it: she's young, she's passionate, she gets to hang around with that Boris.

SVETA: Who?

SASHA: Her youth wing leader. I bumped into them on the stairs.

LYOSHA: Were they kissing?

SASHA: Would have been better if they were. They were talking about this banner she wants to make.

SVETA: So, what's he like?

SASHA: Polite.

LYOSHA: I know him. He came to my uni this week to drum up support. They're always writing about him in the papers.

SVETA: *(To SASHA.)* Do you think it'll be dangerous? I don't want her getting arrested.

LYOSHA: The police won't touch them. They'll stand there for a bit, then they'll disperse. And next year it'll be exactly the same. A few people march, a few people protest.

SVETA: Well I'd rather she was protesting than out clubbing every night. A woman at work's daughter's just become a stripper. I know which I'd prefer. Maybe we shouldn't make a big deal of it; this politics thing is just a phase. It'll pass, you know what they're like at that age.

SASHA: It won't pass until someone sets her straight.

SVETA: Well I can't explain anything to her. And you never even see her, you're out at work till all hours...

SASHA: I need to feed my family.

SVETA: She's always coming back from some meeting or other... You should see her. She gets so angry and says "Let's talk about discrimination about differences in rights." And saying all this, you know, giving me statistics, arguments. Quotations in two languages.

SASHA: Would you go?

LYOSHA: What, d'you think I don't have anything better to do? I'm not planning on living here, remember. I'm leaving the country, then I'm bringing you over to me. Where d'you fancy, Europe or America?

SVETA: Wherever's quietest.

SASHA: How much did you need for those lessons?

LYOSHA: Three hundred.

SASHA: All right, I'll give it to you.

SVETA: *(To SASHA.)* Maybe you should let her go then, if it isn't dangerous. Talk to her before you decide. Just try not to pressure her.

SASHA: I'm not pressuring her. I want to understand...

ANYA returns. SASHA falls silent. Pause.

SVETA: How's Uncle Misha?

ANYA: He was telling me about the War.

SASHA, in silence, exits into another room.

ANYA: Mum, do we have any pieces of fabric? Preferably white.

SVETA: You should at least ask your father about his day at work. Show you care about his opinion on something...

ANYA: He's already expressed enough of his opinions, but fine I'll ask him about work.

SVETA: I'll go and see if we've got any fabric.

SVETA leaves.

ANYA: *(To LYOSHA.)* So what should I write then?

LYOSHA: "Long Live The Red Army!"

ANYA: I'm being serious.

LYOSHA: "Free Drugs For All!"

ANYA: Dick.

LYOSHA: "Age of consent fourteen, age of majority thirty-five!"

ANYA: Are you done now?

SASHA and SVETA enter the room. SVETA is holding a piece of white fabric and some felt tip pens. SASHA hands some money to LYOSHA.

LYOSHA: Thanks. When I get rich I'll pay you back.

ANYA: How's work, Dad?

SASHA: Same as ever.

ANYA: And what's that?

SASHA: Tough client. He approves one set of blueprints, then starts shifting things around everywhere. If I were in charge I'd explain to him that if you start changing little things about a building project then soon enough you'll have to change the whole thing. But our boss won't explain that to him... The customer is always right. *(To ANYA.)* You thought of a slogan yet?

ANYA: No.

LYOSHA: I suggested about ten to her, but she wasn't having any of them.

SASHA: *(Pointing to the felt tips.)* Those won't do.

SVETA: Why not?

SASHA: I'll go get some proper stuff.

SASHA leaves.

SVETA: *(To ANYA.)* You see? Your father doesn't mean you any harm. Just chat to him, explain it. He'll understand why it's important to you.

LYOSHA: There's no way I'd let my daughter go. I'd put her in a cage and keep her there.

ANYA: It's you who needs to be kept in a cage. You're not committed to anything, except boxing and clubbing.

LYOSHA: What about my studies?

ANYA: Yeah right! I know how Dad does all your coursework for you… When you're an engineer you gonna get him to build stuff for you too?

SASHA returns. He rolls out the fabric. Puts the pot of paint next to it.

SASHA: *(To ANYA.)* I've thought of a slogan for you. "Fascism: The Greatest Evil Of Them All!" What d'you think?

ANYA: Cool.

LYOSHA: Only, you should do it in different colours. Fascism in one colour and the rest in another.

ANYA: They gave us red and white paints to use.

SASHA: Why'd you take them? I've got loads. Let's do "Fascism" in black and the rest in red.

LYOSHA: I could draw a little flower next to it…

SVETA: You, my little flower, shouldn't be sitting there watching. Go and read, or do something useful.

LYOSHA: I think I'll read.

LYOSHA leaves.

SVETA: Do you need my help?

SASHA: We'll manage.

SVETA leaves. SASHA starts painting the letters. ANYA watches.

SASHA: So who's going to be there tomorrow?

ANYA: They're all good, honest people. The Russians, I mean. Latvians support the Nazis. Russians stand up for their veterans. Uncle Misha, for instance.

SASHA: Do all Latvians support the Nazis?

ANYA: Practically all of them.

SASHA: So not all of them?

ANYA: Dad! *(Pause.)* That's not what I mean. Of course they don't physically attack us Russians. But when they all get together, you think they don't see us as the enemy?

SASHA: Well there's our other neighbour, Valdis, he's a Latvian.

ANYA: We say hello. That's it.

SASHA: In what language?

ANYA: Him in Latvian, me in Russian.

SASHA: And?

ANYA: Nothing.

SASHA: So you can live next door to him, say hello?

ANYA: Dad, I don't understand what you're trying to say.

SASHA: What I'm trying to say, is there's no place for children on the barricades. Whatever happens, even if there's a war. There's no place for them. All issues like this should be decided by grown-ups.

ANYA: Well I'm a grown-up too now, you just haven't noticed.

SASHA: Maybe. *(Pause.)* You know the Latvian Legion was a frontline unit, don't you? They weren't a death squad.

ANYA: I know.

SASHA: And a lot of them didn't even fight, they just… served – did guard duty, were drivers, protected the communication lines.

ANYA: We did all about it in history.

SASHA: They were put on trial after the War…

ANYA: They put them on trial, and now they're heroes. If you've got the letters "SS" on your arm then what are you? A bunny rabbit? They're Nazis, Dad, Nazis.

SASHA: Pass the paint.

ANYA hands him the pot. SASHA continues making the banner.

ANYA: It's not about them, anyway.

SASHA: Then who is it about?

ANYA: These old Nazis have become symbols of Latvian independence. Don't you get it? There's nowhere else in a situation like this. Only Latvia.

SASHA: They're old men.

ANYA: They're still Nazis. And they told us in the party that lots of young people are marching with them this year. Young Latvian nationalists. And what about us? If we're silent today, tomorrow…

SASHA lifts up the banner.

SASHA: Well, what do you think?

ANYA: Beautiful.

SASHA puts the banner on the floor.

SASHA: There's no need to be silent, of course… Let it dry.

ANYA: That was fast work, Dad. Thanks.

SASHA: Well don't expect my help if you're going to start making bombs.

ANYA: Yeah, well bombs are much harder to make.

SASHA: So you've decided for definite then, nothing's going to talk you out of it?

ANYA: Yeah.

SASHA: Great. I'm going too tomorrow, then.

ANYA: Where?

SASHA: To the Legionaries' parade.

ANYA: Dad, there's no need!

SASHA: Yes, there is. There definitely is. I'll come and stand next to you, keep an eye on you. Join your party for the day!

ANYA: Dad, everyone'll laugh at me.

SASHA: By everyone you mean Boris?

ANYA: It's got nothing to do with Boris.

SASHA: He'll be delighted to see me, he'll have himself a new recruit!

ANYA: Fine, fine, go then. I'm not going. Stand wherever you want.

ANYA stands and exits into another room. SASHA watches her go.

SCENE 4

16ʰ March. Afternoon. Two old men, breathing heavily, approach the left-hand door. They are strangely dressed, in uniforms which look like German ones from the Second World War. Each has medals on his chest: crosses. The owner of the flat tries to open the door.

VALDIS: Stupid lock.

PAULIS: *(Holds out his plastic bag to VALDIS. The contents clink together.)* Let me do it…

VALDIS: I'm nearly there. Don't drop that bag. Are you listening to me? Paulis!

PAULIS: Why are you shouting? I'm not deaf. Well?

VALDIS: Nearly there…

The lock clicks. The door opens. Both men enter VALDIS' flat.

PAULIS: You're already old, Valdis. You can't even unlock your own door. Where shall I put this?

VALDIS: Don't take your shoes off. Put it in the kitchen.

PAULIS: *(Going to the kitchen.)* You'll probably start pissing in your trousers soon, Valdis.

VALDIS: I already do. Whenever I have to look at a moron like you. Because I'm laughing so hard.

VALDIS also goes into the kitchen, where PAULIS is unpacking bread, sausage and vodka and putting it on the table. VALDIS puts the vodka in the fridge, and starts to help his friend lay the table.

PAULIS: *(Looking around.)* You've done all right for yourself. I'll be round here every day.

VALDIS: You can help me do it up. I haven't touched the place in years.

PAULIS: Could you shut those blinds?

VALDIS: Cut thinner slices of that sausage, Paulis. You're in my house now.

PAULIS: That's what I'm saying, the sun's in my eyes.

VALDIS: Thinner slices of cucumber too…

PAULIS: Well when the sun's in my eyes, I can't cut at all. I just want to drink.

VALDIS: Well shut the blinds then if you need to.

PAULIS: Let's just have a drink instead.

VALDIS: What's the hurry? We'll lay the table, then we'll sit down, then we'll put some music on. You're like a little boy: "I want sweets, give me sweets."

PAULIS: Have you got any sweets?

VALDIS: I've got everything. Come on. Sit down.

PAULIS sits down at the table. VALDIS retrieves the vodka, stands in front of the table.

PAULIS: What?

VALDIS: I should go and get my neighbour.

PAULIS: What neighbour?

VALDIS: From across the hall. He was in the War too.

PAULIS: Then go and get him.

VALDIS: He's a sniper. He's got these three medals…

PAULIS: Iron Crosses?

VALDIS: No. Orders of Glory… Sort of stars.

PAULIS: He's Russian?

VALDIS: Of course.

PAULIS: What kind of an idiot are you? I can hardly believe
my ears.

VALDIS: I was joking.

PAULIS: No, just you go and fetch him. I'll drink a shot. Then
I'll punch him in the face.

VALDIS: All right, we'll fetch him later. But he's a tough old
dog, you'll have to watch he doesn't punch you first.

VALDIS sits at the table. He pours out vodka into shot-glasses.

VALDIS: Come on then, to everyone…

The old men drink their shots then eat a bit of food.

PAULIS: Now I'll say a toast.

VALDIS: What's the hurry?

PAULIS: I'll just say it, then forget about it. Right… You,
Valdis, you and others like you, and me as well, so us,
essentially. It was us back then, in the War, back then it was
all of us who took the first steps to ensure that our Latvia
could decide for herself, without those Soviets or anyone
else, how she wanted to live. Together we… We didn't fight
for Hitler… Everything we did we did for our Homeland.
Therefore my toast is to our government, which gave us,
the people who fought for their Homeland, the opportunity
today, on the sixteenth of March, to lay our wreaths, and

to wear our uniforms. Of course it's a shame that it's only one day…

VALDIS: I couldn't care less about the government.

PAULIS: Well I don't know about you, but I thought it was nice today, I enjoyed it… I enjoyed marching under our flags, I enjoyed it when the people there clapped us.

VALDIS: Not all of them.

PAULIS: I'm not talking about the Russians. *(Pause.)* And there were politicians there too, marching along with us.

VALDIS: Not all of them.

PAULIS: Enough of them were there. The President sent a letter of congratulation… That means they appreciate what we did.

VALDIS pours out more vodka.

VALDIS: Well come on then. To the sixteenth of March… To the Latvian Legion.

PAULIS: To the fallen…

VALDIS: No, that's the third toast.

PAULIS: Fine. Did you want to put some music on?

VALDIS and PAULIS drink their shots. VALDIS stands and turns on a small record player. A Second World War German march plays softly.

PAULIS: I marched through Riga to this, just after they called us up. Good music.

VALDIS: Me too.

PAULIS: There were girls holding flowers everywhere… I remember one of them. Her breasts. Like truck wheels.

VALDIS: What, dirty?

PAULIS: No, round. *(He shows him with his hands.)* They don't make them like that any more. Now it's all dyed hair and skinny as alley cats. I'm worried there won't be enough sausage.

VALDIS: There's more in the fridge.

PAULIS: And the dresses back then, too. And the arses underneath. And you couldn't tell if the arse was big or small because of the dress.

VALDIS: Do you like them big?

PAULIS: Mostly, yes…

VALDIS: When I was taken prisoner the Russians had this woman at their HQ, a major… When she was sitting opposite me, interrogating me, I couldn't even think straight. And when she stood up… her arse was as wide as this table. You should have seen her.

PAULIS: I had a bloke interrogating me.

VALDIS pours out more vodka.

VALDIS: Come on, to the fallen, to the Latvians.

PAULIS: And to the day, when there's not a single Russian left in Latvia.

VALDIS drinks his shot in silence. PAULIS after him.

SCENE 5

The hallway. SASHA climbs the staircase and approaches the middle door. He opens the door. His wife is there to meet him.

SASHA: Centre of town's a nightmare. They were piling the monument with flowers. Police everywhere. TV cameras. Nowhere to park. I had to go by the river.

SVETA: Why were you in the centre of town today?

SASHA: To check up on our daughter.

SVETA: And did you see her there?

SASHA: Mmm.

SVETA: And did she see you?

SASHA: No.

SVETA: Why you looking so pleased with yourself?

SASHA goes into the kitchen. SVETA dishes him up a bowl of soup. SASHA starts eating.

SVETA: Didn't you decide she wasn't going?

SASHA: She decided herself she wasn't going.

SVETA: But she went anyway?

SASHA: Yep.

SVETA: There wasn't any trouble there, was there?

SASHA: Nope. You know, they were stood there, all these young girls, young, decent girls… Why do they need to fight? Why do they need demonstrations? Why do they need protests? They just need to get married. What are they fighting for?

SVETA: They're fighting for their rights. Rights for Russians.

SASHA: *(Eating.)* So why weren't you there then? She's a Latvian citizen. She speaks Latvian. What's the problem?

SVETA: Maybe she wants to be a politician.

SASHA: Then yes, she ought to be fighting for something.

SVETA: I'll take it up with her when she gets back. She shouldn't be lying to her father.

SASHA: That won't make any difference.

SVETA: So I just shouldn't say anything?

SASHA: There's no need.

SVETA: What d'you mean?

SASHA: When I saw her there I went over to one of the television cameras and told them exactly what I think. We can all sit down together and watch it later. If they haven't cut me out of the report, that is. Don't tell Anya, though. Let it be a surprise.

SVETA: Well can I at least tell Lyosha?

SASHA: You can tell him.

SVETA: What channel will it be on?

SASHA: On channel one, the Russian channel. This evening. Everything all right at work?

SVETA: They let us out early today, so they could do some work on the computer network. So what did you say to the camera?

SASHA puts his arms round his wife's waist. Pulls her towards him.

SASHA: I had some pretty convincing arguments. When did you say the kids'll be back?

SVETA: Come off it. They'll be back, as always, at the worst possible moment.

SASHA: We can be quick then.

SVETA: *(Laughing.)* Hey! Mr TV star! What's got into you?

SASHA: Come on. Right now.

SVETA relents and sinks into her husband's arms. The doorbell rings. SASHA, swearing, goes to answer the door. LYOSHA enters.

LYOSHA: The door was locked, I couldn't get in.

SVETA: You hungry?

LYOSHA: Starving.

SVETA puts a bowl of soup in front of her son. LYOSHA eats.

SVETA: Your dad'll be on the evening news. He gave an interview about the Legionaries. For channel one.

LYOSHA: Wow. *(Looks at his watch, then at SASHA. SASHA is silent, reading the newspaper.)* We don't have long to wait.

SVETA: Just don't tell Anya.

LYOSHA: Why not?

SASHA: She was down there too. Let's give her a surprise.

LYOSHA: What did they ask you?

41

SASHA: They asked me if I needed to thrash my daughter for lying to her parents.

LYOSHA: Definitely!

The sound of keys in the door. Everyone falls silent. ANYA enters.

LYOSHA: Here she is, your darling daughter.

ANYA: Hey Mum. Hey Dad. How was your day?

SASHA: Not as eventful as yours.

ANYA: What d'you mean?

SVETA: If you said you weren't going then you shouldn't have gone.

ANYA: Mum I couldn't not go. I didn't think anyone would be there checking up on me.

SVETA: Your dad was just passing by. He had a meeting in the centre of town.

LYOSHA: You should have grabbed her banner and smacked that Boris round the head with it! Sparked an international conflict! Dad: the hero of the day!

SVETA: As it happens, he is the hero of the day.

SASHA: Did you go into school at all today?

ANYA: I excused myself.

ANYA sits down next to her father and embraces him.

ANYA: Dad, I'm sorry. I just, I couldn't not go.

SASHA: Well, you felt you needed to make a stand.

SVETA: *(To ANYA.)* Did everything go okay? Peacefully?

ANYA: Yeah. *(Pause.)* It was even a bit boring.

LYOSHA: What did you want, people to start shooting?

ANYA: No. But... *(Pause.)* In books people sacrifice their lives for ideas. And then people build monuments to them. Children bring flowers to the monuments. It's beautiful.

LYOSHA: By the time you've got a monument you're not gonna care about that.

ANYA: But to have a monument built to you, you have to do a lot more than stand there holding a banner.

SVETA: Your father told you not to go.

ANYA: I don't regret it, Mum.

LYOSHA: Mum, are there seconds?

SCENE 6

VALDIS' flat. He and PAULIS are sitting at the table. The bottle of vodka is nearly empty. VALDIS has taken off his military jacket and has hung it on the back of his chair.

PAULIS: And then the commander says to me, "If everyone were like you, we would have won the War a long time ago."

VALDIS: It wouldn't have made any difference. Nothing good would have come out of it anyway.

PAULIS: Well I don't know what would have come out of it, I know what actually came out of it. Eight years in a Soviet prison camp… Guards on my back, criminals, officers. And not once, would you believe, not once during the War did I ever fire my rifle at anyone. All I did was guard duty.

VALDIS: And you're saying you would have won the War.

PAULIS: Well a Latvian goes where he's ordered and does what he's told. And after I got out of the camp I was ready to kill every Russian I saw with my bare teeth.

VALDIS: And now you'd have to use your dentures.

PAULIS: I couldn't even manage to find work after I got out. Some pig sat in an office, straight off the train from Siberia, speaking worse Russian than I do, takes one look at my papers and tells me they won't take me. This place, he says, is immensely important to the Russian nation. It's a bread factory. And he's scared I might poison the flour.

Idiot. Him and his woman even go to our theatres. Both of them disgustingly fat. And she's got this velvet dress on that looks just like my father's curtains. Already all worn away on her arse. And they walk along like this and he doesn't care, he just throws his cigarette ends on the pavement when there are little bins outside every house.

VALDIS: You should have taught that woman a thing or two…

PAULIS: I'd have had to take a three-day shower afterwards. *(He stands.)* And all the time I'm being "called in for a chat". And I told them, you already know everything. I've already been in prison for eight years… I planted a bloody forest for you – what do you want me to do, build you another Kremlin? But no. I'm called in again. And I'm questioned again. The same questions. And then the questions stop altogether. I turn up and we just sit there in silence for half an hour. He puts a tick in the box and I go. If I had my way I'd have them all up against the wall and shot!

VALDIS: Sit down. You're embarrassing yourself.

PAULIS: *(Stays on his feet.)* And nothing's changed! Independence! They're still throwing their cigarette ends on the pavement without a care in the world!

VALDIS: Sit down. Let's have another drink, there's still some left.

PAULIS sits. The old men down their shots.

VALDIS: That's just our fate. We were born on a crossroads. If the Swedes ever wanted to get somewhere, or the Russians, or the Germans, or the Poles, they've always gone through us. And many of them stay. We're the beautiful place in the middle. Remember how many Germans lived here before the War? Now they've all gone. It'll be like that with the Russians soon too.

PAULIS: Hitler called all the Germans back home. But no one's calling the Russians back anywhere. Did you see them

today? Stood there with their banners. Do they think I don't know how to read Russian? Young ones there too.

VALDIS: There were lots of young ones marching with us as well.

PAULIS: And that's the only thing that made it worthwhile. They beat us then and they're still beating us now and I hate it. It's like they're sitting in my home eating my food and I hate it and I can't do anything about it.

VALDIS: Shall I go and fetch my neighbour?

PAULIS: Fuck him, fuck your neighbour. Forty years ago I could have taken him… but now… I can't even lift this glass.

VALDIS: Your lifting seems fine to me.

PAULIS: *(Standing up again.)* It's not funny, Mr Valdis, it's not funny. *(Slams his hands down on the table.)* So what about you… have you forgiven them already?

VALDIS: I didn't sit in a prison camp for eight years.

PAULIS: Hm. How many years did you do then?

VALDIS: Seven.

PAULIS: Ha! *(Moves away from the table, looking at VALDIS.)* Maybe your mother's Russian.

VALDIS: No. Latvian.

PAULIS: What would she say to you now?

VALDIS: She died a long time ago. After she buried my two brothers she didn't last a year.

PAULIS: Were they killed?

VALDIS: They were blown up. An unexploded shell left in the woods after the War.

PAULIS: You see…

VALDIS: How would I know who left that shell there? It could have been the Russians, it could have been the Germans. What's the difference? Why are you clutching your chest?

PAULIS sits down with his hand over his heart. He is breathing heavily.

What's wrong? Shall I call an ambulance?

PAULIS: My pills... they're in my coat pocket... could you fetch them...

PAULIS loses consciousness. VALDIS checks for a pulse. He picks up the telephone, dials and speaks into the receiver.

VALDIS: Ambulance? My friend's collapsed... I've undone his buttons. He's breathing. He's in his eighties. Yes. Of course we've been drinking. No, I don't know how. Flat thirty-four, fifteen Vaidavas street. Valdis Vapalis. Yes. No, there's no one close-by for me to call. Fine. I'll leave the door open.

VALDIS quickly goes and rings SASHA's doorbell. The door is opened to him, and he enters.

VALDIS: Help. Please!

SASHA, SVETA and ANYA look at VALDIS. LYOSHA stops eating. Those who were sitting down rise to their feet.

VALDIS: My friend's collapsed. He needs a doctor. I've called an ambulance...

SVETA: Yes, just... Sasha there's a doctor in the next block...

ANYA: There's a first aid kit at Uncle Misha's. *(She runs out.)*

SASHA: Lyosha, run fetch the doctor! Sveta, get some water!

Everyone rushes to perform their tasks, then VALDIS, SASHA and SVETA (carrying the water) run into VALDIS' flat. PAULIS is sitting in the same position. He is unconscious. SASHA immediately picks him up and lays him out on the floor. ANYA runs in with the first aid kit.

ANYA: Out of the way!

ANYA listens to PAULIS' chest, straightens up, checks his pulse.

Give me something to put under his head.

VALDIS grabs his jacket and gives it to ANYA. UNCLE MISHA enters. ANYA looks at UNCLE MISHA. UNCLE MISHA looks at PAULIS' jacket, which is hanging from the back of his chair. ANYA notices the jacket in her hands. UNCLE MISHA turns and leaves. ANYA stands.

SASHA: *(To SVETA.)* Pass me the water! Anya!

LYOSHA runs in.

LYOSHA: He's not in. His car's not there.

SASHA: Anya, do it.

ANYA: What?

SASHA: Something!

ANYA: No.

Pause.

SVETA: Anya, this person's unconscious.

ANYA: They're not people.

ANYA turns and leaves.

SVETA: *(To VALDIS.)* So sorry about that.

SASHA: Sveta, go and meet the ambulance.

LYOSHA and SVETA leave. SASHA and VALDIS look at one another. SASHA is down on his knees, holding PAULIS' head. UNCLE MISHA enters with an oxygen mask and tank. He stands in the doorway.

SCENE 7

SASHA's flat. ANYA is sitting on the sofa, her knees pulled up to her chest. LYOSHA is looking out of the window.

LYOSHA: The ambulance is here.

ANYA is silent.

I said, the ambulance is here.

ANYA: I heard you, I'm not deaf.

LYOSHA: Dad's gonna go mental when he comes back.

ANYA: I don't care. Just coz someone in this family has actual views...

LYOSHA: Oh get off your soapbox. If you didn't want to help him you should have just said: "I'm not qualified to help, you'll have to wait for a real doctor."

ANYA: That'd be dishonest.

LYOSHA: Coz you're really honest, aren't you? You've already been to one protest today. Why are you turning our home into another one?

ANYA: Because I am!

LYOSHA: You should have left your bullshit at the march!

ANYA: It's not bullshit it's justice.

LYOSHA: Come here then, watch them carry out your justice on a stretcher.

ANYA: He'll be fine. He had a pulse, his heart was alright. Bit of arrhythmia combined with too much alcohol.

LYOSHA: *(Beckoning ANYA to the window.)* Look.

ANYA goes to the window. SASHA and SVETA enter. ANYA sits back down on the sofa. SASHA starts pacing around the room. SVETA is standing in the doorway.

ANYA: *(To SVETA.)* Why are you looking at me like that?

SASHA: God, I can't believe I let it go this far... What kind of a medical school is going to take you?! What kind of a bloody surgeon are you going to be?! After that performance you shouldn't even be allowed to apply!

ANYA: Maybe I won't then. *(She turns on the television.)*

SVETA: What do you mean you won't? Do you have any idea how much money we've already spent...

SASHA: Sveta! Why are you bringing money into it? Our daughter just killed someone.

ANYA: I didn't kill anyone. I saw the ambulance take him away. He's alive.

SASHA: And if he dies in the ambulance? You could have helped him. And you didn't! There are certain times when any normal human being…

ANYA: So I'm the abnormal one am I? When you were perfectly happy to save a Nazi! And Mum too! And Lyosha! They should give you all medals, make you honorary Latvians!

LYOSHA: Awesome.

SASHA: We don't need medals. We just need you to explain yourself. Why do you hate them all so much?

ANYA: I don't hate them all, I just hate Nazis! Those old ones marching along in their ranks, and the new ones handing them bunches of flowers! Why did these monsters get to walk around my city today? Who wrote the law that allows them to have a parade? Me? You? No: them. The Latvian government. A government that makes half the people who live in this country prove they have the right to live here. You were born here and you're not even citizens! Why should you have to take exams in Latvian language and history? Why should you have to sing the national anthem? And have you seen the history they want to make you learn? It's delusional!

SVETA: *(To ANYA.)* It doesn't matter, you should have helped that old man.

ANYA: Maybe in another country I would have helped… But if we don't fight them today then tomorrow they'll be putting us in concentration camps! Until we change this country people have to make a stand!

SASHA: Some people are better than that.

ANYA: Like you, Dad?

LYOSHA: Shut up, Anya, shut up! Leave Dad alone.

LYOSHA turns up the television. On the screen there are ranks of Legion veterans marching up to put flowers on a memorial. They are surrounded by police. The newscaster appears.

NEWSCASTER: Today, on the sixteenth of March, the state of Latvia, which attests to being a civilised, modern, European country, showed its true face to the world. Elderly Latvian Nazis, former soldiers in Hitler's army, an army responsible for spilling the blood of millions upon millions of people, today celebrated their special day. Latvian SS Legion Day.

On the screen: shots of the veterans marching under their flags. Voice of the newsreader.

It is, indeed, surprising. The whole world, regardless of nationality and skin colour, condemned fascism at the Nuremberg Trials. The whole world, except for Latvia. Look at the faces of these soldiers. Maybe one of them killed your father, your grandfather, your brother or your husband. Maybe one of them torched villages and raped women. We will never find out. Because in Latvia, they are untouchable. In Latvia, they are heroes.

An elderly woman in a pink beret appears on the screen.

WOMAN: These Nazis should be put in prison. They can worship their Hitler from there. My entire family fought on the front, and I just can't watch this.

NEWSCASTER: Why are you here then?

WOMAN: I'm here so they see what we think of them. So they don't get any more special holidays!

ANYA: Shame they didn't ask me to go on TV, I'd have had something to say.

LYOSHA: You've said enough for today.

On the screen Legion veterans are putting bouquets at the foot of a monument.

NEWSCASTER: Unfortunately in modern Latvia veterans of the Soviet Army, which, incidentally, consisted of a great many Latvians, are not afforded the same honour and respect as the SS evildoers they routed. But things will change. We hope that the international community will explain to the powers-that-be in today's Latvia, what exactly fascism is, and how it should be treated.

LYOSHA: Dad, it's you!

SASHA appears on the screen.

SASHA: I'm a Russian man who's lived his whole life in Latvia. My daughter is stood over there with a banner. On it is written: "Fascism: The Greatest Evil Of Them All". I wrote those words myself. I wrote them, even though I really didn't want her to come here today. No, I really didn't want her to come but, all the same, she's here. People of Latvia, please try and explain to your children that there's no need to fight with anyone. There's no need for this uproar over these old men. This isn't any kind of propaganda. They've just come out here today to remember their fallen comrades. There are fewer and fewer of them every year. We should probably just think of them as human beings. They're just like us, only they've seen much more hardship in their lives. That's all there is to it.

NEWSCASTER: We have specifically chosen to broadcast the opinions of this man, to show normal people that fascism is alive and well. And it's alive and well thanks to Nazi sympathisers like this. The governments of many countries have already expressed...

ANYA abruptly turns off the television. She looks at her father.

ANYA: Said enough have you? You're a hundred times worse than me. I didn't help one man, but you betrayed your entire people. Are you happy?

ANYA leaves the room.

LYOSHA: I'm gonna go do my English.

LYOSHA leaves.

SVETA: Well maybe no one even watched it. There were soaps on the other channels…

SASHA says nothing. He looks at his wife.

SCENE 8

UNCLE MISHA's flat. ANYA is crying. UNCLE MISHA is stroking her head.

ANYA: How will I look anyone in the eye now? Everyone I know probably saw it.

MISHA: Don't cry.

ANYA: Why did he even go down there? What was it he wanted? He should have stayed at work. He's never been interested in anything I do. I tell you far more than I tell him. I'm nothing to him! I'm nobody! I work hard at school and that's all he cares about. He has no idea what's important to me! He'd rather help a Nazi than listen to his daughter! But I didn't help him! I left straight after you!

MISHA: I went back.

ANYA: With your rifle?

MISHA: My oxygen mask. I killed enough of them at the front.

ANYA: You didn't, Uncle Misha, you didn't!

MISHA: I used to play chess with Valdis. He's not bad. I asked him: "Where did you learn to play like that?" "In the gulag," he told me. I asked him why he was in the gulag, and he told me he was in the Legion. We stopped playing chess after that. And haven't played for twenty years... We're soldiers, Anya. And we're going to die soon.

ANYA: I thought you'd shoot them till you ran out of bullets. You've surrendered.

MISHA: The War is over.

ANYA: No it's not, Uncle Misha. It's not.

ANYA stands and leaves.

SCENE 9

17th March. Evening. SASHA is returning home. His wife is in the hallway, trying to clean off a white swastika, which has been painted on their door. They exchange glances.

SASHA: *(Indicating the swastika.)* Leave it.

SVETA continues cleaning the door.

I'm telling you to leave it.

SVETA throws the cloth into the bucket. She goes into the flat. SASHA after her.

We should report it to the police.

SVETA: Report it then.

SASHA: *(Raising his voice.)* Monsters! It's someone from our block did this… *(To SVETA.)* Why aren't you saying anything?

SVETA: My mum called, people in Russia watched it too. Everyone watched it. I can't even leave the house.

SASHA: What's it got to do with you?

SVETA: Oh, nothing… Didn't you see the papers today?

SASHA: I was down at the site. I finished up and came straight back here.

SVETA: You're the top story. You've overshadowed the Legionaries. I went out into the courtyard. People staring at me from every window. Oh! There goes the wife of that traitor, off to feed him, off to cook him some cutlets. Eat up, my love, eat up! There you go, cutlets made from Russian children.

SASHA: Pork suits me fine, actually.

SVETA: Well you'll need to earn a bit more money, my love, if you want to afford pork. I got the sack today.

SASHA: The sack?

SVETA: Boss's secretary brought me a letter round this morning: "Unavoidable redundancies." Budget cutbacks, apparently. My services are no longer required. I was too upset to call you.

SASHA: How can they do that?

SVETA: Because my husband is such a principled man.

SASHA: That's ridiculous!

SVETA: Unfortunately my boss doesn't see it that way. He, unfortunately, is Russian. And he, unfortunately, doesn't hold the same opinions as you! Or if he does at least he doesn't voice them.

SASHA: But why give you the sack?

SVETA: Because we built this entire fucking country and we're not even thought of as people. If it wasn't for us they'd all still be peasants.

SASHA: We built it and then we destroyed it ourselves in the War.

SVETA: Oh isn't that the truth! You should go on television and say that. Don't you think?

SASHA: Sveta! You... Don't you see what's happening?

SVETA: Oh I see it. Anya was right about a lot of things you know. Not about everything. She should have helped that old man... But everything else... I'm going to wash off this swastika but it'll only get painted on again tomorrow.

SASHA: Sveta! I never said I was a Nazi. Surely you should understand. You're my wife aren't you?

SVETA: No Sashenka, I don't understand you. And I'm scared the children don't understand you, either. What's going to happen to them?

SASHA: Where are they?

SVETA: Lyosha's at boxing. When Anya left this morning she looked like she'd been crying all night. Why did you do it? We all know how we live here. We're like aliens. It's them, it's the Latvians who have done this to your daughter. Do you want to become one of them?

SASHA: I don't want anything any more. I'm sorry I went over to that moron with a microphone. I'm sorry for what I said, I'm sorry for what I think. I'm sorry I was ever fucking born. Will that do?

SVETA: Right, well go on television again and tell them that you're sorry.

SASHA: In your dreams.

SVETA: Well then at least clean the door.

SASHA: I'll clean it. But we should get something to eat first... or aren't you going to feed me?

SVETA: Certainly. It's cutlets.

SASHA laughs nervously. LYOSHA enters.

LYOSHA: What's up with the door?

SVETA: We're washing off a swastika.

LYOSHA: Right... Where's Anya?

SVETA: She's been out since morning. Her phone's off.

LYOSHA: I'm gonna catch whoever painted that swastika...

SASHA: Swastikas are crap. Swastikas can be washed off. Your mother got the sack... it upset that stupid boss of hers.

LYOSHA: What, the fat-face? What was his problem?

SASHA: He's Russian. And, as it turns out, an activist.

LYOSHA: Are they only taking idiots as activists now?

SASHA: Clearly...

LYOSHA: Don't worry Mum, you'll find another job. This country's full of idiots! Something happens a hundred

years ago and they still keep banging on about it: The Russians this, the Latvians that. I'm fed up of it! You all sit there wondering who's gonna run our great Latvia. There are more people in one district of Shanghai than there are in our entire country!

SVETA: We don't live in Shanghai, though, Lyosha. We live here...

LYOSHA: Oh stop it, Mum. Look around you. The world's changed. There are no borders any more. People travel, find new ways to live. They get married, they have children. They work wherever the wages are best. They live wherever it's best to live. And that's fine. And it's been fine for ages! No one cares any more what nationality you are, or where you come from! No one cares what colour skin you have! Me, for instance, I really fancy black girls! And so what?

SVETA: I'm not sure I'd be ready for...

LYOSHA: You'll get used to it, Mum... Your grandkids'll have beautiful dark skin.

SVETA: And what language will I talk to them in? Russian?

LYOSHA: If it were up to me, I'd make everyone speak one language: English, Spanish, Chinese, I don't care. You can learn a language in a year. Imagine it: the whole of Latvia speaking Spanish. I really don't know what we're all fighting about, when everything could be so simple.

SASHA: This is just what I was saying yesterday. Whilst we're all still so obsessed with harming each other nothing good can ever happen.

SVETA: *(To LYOSHA.)* You want something to eat?

LYOSHA: I'm going out. Just for a couple of hours.

SVETA: Don't be too long. And… if someone says something please don't react.

LYOSHA: No one's gonna say anything.

SASHA: *(To LYOSHA.)* Be careful.

LYOSHA leaves.

SCENE 10

VALDIS' flat. VALDIS and PAULIS. Both are dressed in casual clothes.

VALDIS: You gave me a fright yesterday.

PAULIS: I even gave myself a fright. And my family. They didn't leave my bedside all night. It's nothing. I woke up this morning feeling like a new recruit. My great-granddaughter ran in and asked me: "Granddad, did you see Hitler yesterday?" "No, little one," I said. "My eyesight is bad."

VALDIS: Does she know?

PAULIS: She knows.

VALDIS: Mine don't. They don't know Hitler, they don't know Stalin... They know Madonna.

PAULIS: Who?

VALDIS: Some kind of actress. I think it's a good thing they don't know...

PAULIS: Well I disagree. We're not in the Soviet Union any more...

VALDIS: Calm down. You didn't agree with me yesterday and look how that turned out.

PAULIS: That was yesterday! We were drunk!

VALDIS: You're not allowed to drink.

PAULIS: I'm allowed to drink, I'm just not allowed to get worked up. That's what the doctor said. But how can I not get worked up? It's stressful enough round here to give even a healthy person a heart attack.

VALDIS: Well you try and talk to me about mushrooms, or about the weather. About fish maybe. About women... but

as soon as we even start the conversation it immediately turns to politics or to the Russians.

PAULIS: But how can we get away from it? Even just now climbing up the stairs I ran straight into a swastika. Maybe they wanted to do it on your door, but got the doors confused? Someone painted one on my door once, too.

VALDIS: No, they were aiming for my neighbour's door. He was on TV yesterday. He was interviewed about us. He said it's time to forgive and forget et cetera et cetera.

PAULIS: He should tell the police.

VALDIS: He's Russian.

Pause.

VALDIS: I watch the Russian channels. Force of habit.

PAULIS: They were right to draw that swastika.

Pause.

VALDIS: What?

PAULIS: I don't need his forgiveness. And nothing needs to be forgotten. What have I done that needs forgiveness? Let him go back to Russia, he can forgive everyone there.

VALDIS: When you collapsed yesterday his whole family helped out. The doctor was Russian too, by the way.

PAULIS: Did I ask them to do that?

VALDIS: I asked them to do that.

PAULIS: A Russian…

VALDIS: Just don't you get upset.

PAULIS: I'm not getting upset. Who's he to judge me?

VALDIS: He probably had good intentions.

PAULIS: Well I don't need his good intentions. I don't need anything from them. It's me who should be forgiving them.

Me! Forget... What's the point in living if we're not going to remember? Is he young?

VALDIS: He's not a boy.

PAULIS: Everyone should live in their own home. And if they live in someone else's, they should sit quietly and respect their hosts. If they need something, they should ask for it. Am I wrong?

VALDIS: You're going to start clutching your chest again.

PAULIS: Look what's happening in the world. Arabs in France, Blacks in England, Turks in Germany. What are they doing there?

VALDIS: They were invited there. To sweep the streets...

PAULIS: But who invited the Russians here? You don't know? They came here by themselves.

VALDIS: I think my neighbour was born here. He's about forty. He's polite. He always says hello. He never plays loud music, even though he has children.

PAULIS: So he's the son of people who turned up in tanks. And music is hardly the issue.

VALDIS: You're right, music isn't the issue.

PAULIS: Do you want me to go and say thank you to him? I'll go and say thank you to him! Right this minute! We Latvians don't just know how to fight...

The doorbell rings. VALDIS goes to answer it. He returns accompanied by a young man in a suit. The young man is carrying a small cardboard box.

GINT: *(Turning to PAULIS.)* Mr Vapalis...

PAULIS points to VALDIS.

Excuse me. My name is Gint. *(To VALDIS.)* Our party...
Oh, by the way, here's a pamphlet about us if you'd like to have a read. *(Hands VALDIS a small pamphlet.)* Our party

considers it our responsibility, so to speak, to congratulate every veteran personally… Yesterday we weren't…

PAULIS: What about me?

GINT: I'm sorry, you're a veteran too? Which district are you from?

PAULIS: Central district.

GINT: That's not mine, I'm only responsible for this one. But we'll certainly be paying you a visit too… One of my colleagues some time in the next few days… So. Our party gratefully honours the memory of those who fought for Latvian independence and is prepared to help veterans not just with words, but with deeds. Here is a small token of our appreciation. *(Hands VALDIS the box.)* And if it's not too much trouble, please have a look at our pamphlet. Later.

VALDIS: Would you like some tea?

GINT: I don't have much time. I have other veterans to visit…

VALDIS: Many?

GINT: A handful.

PAULIS: I'm sure you could spare five minutes… you can tell us about the party.

GINT: *(Sitting down.)* Okay. I can take five minutes.

VALDIS: You've got a tough job, my boy…

GINT: Well… It's not really work to me…

PAULIS: All the same, you're on your feet all day.

GINT: Yes, of course. But, you know, I just think about everything you two had to go through. In the War, and afterwards… And when I think about that, my feet don't hurt as much…

PAULIS: Well, that's just the way things were back then…

GINT: I'm just sorry I was born too late. And many of us in the party feel the same way. We've got democracy now. We don't shoot, we talk.

VALDIS: Shooting's far more scary.

GINT: Well let them shoot. I'm not scared.

PAULIS: Yes, we live in different times now.

GINT: The thing is that there's no consensus amongst Latvians...

VALDIS: And just where have you ever seen all people thinking the same?

GINT: Well, they can think different things, but everyone needs to remember. Not once in my life have I ever shaken hands with a Russian. And I know that I never will.

PAULIS: Are there lots of young people like you in the party?

GINT: Lots. We wish there were more, of course...

PAULIS: *(To VALDIS.)* I told you.

VALDIS: *(To PAULIS.)* Are you talking about politics again? *(To GINT.)* He had a turn yesterday, he's not allowed to get worked up...

GINT: I'm sorry.

PAULIS: I can talk about this sort of politics. The decent sort.

GINT: *(Takes a notepad and pen out of his pocket. To PAULIS.)* Write down your address for me. Once I've worked out how next week'll pan out, I'll arrange a time to come over to you. We'll have a proper chat. But for now, I'm sorry, I really don't have any time, there are other veterans waiting. *(To PAULIS.)* Do you have any kind of ID on you? For confirmation...

PAULIS: Yes, I'll just go and get it. It's in my coat.

PAULIS goes into the corridor to fetch his ID.

VALDIS: By the way, there's another veteran living across the way. You should pop by, congratulate him too.

GINT: That's strange, he's not on my list.

PAULIS returns, shows GINT his ID. Writes down his address. Gives the notepad back to GINT.

PAULIS: I'm almost always at home.

GINT nods. He shakes hands with the old men and leaves.

SCENE 11

GINT rings UNCLE MISHA's doorbell. The old man opens the door. GINT goes straight into the room. UNCLE MISHA follows him.

GINT: I'm really sorry, you seem to have been left off my list. I'll just go down to my car and get you your gift box. We, our party, are the only ones who endeavour not to forget our veterans on their special day. I want to say, that we remember all of our veterans by name and *(Taking out his notebook.)*... speaking of which, I'll take yours down straight away...

MISHA: What day? Who've you come to congratulate?

GINT: I was told that you were in the Legion too.

MISHA: The only time I've seen that Legion of yours is through my sniper's scope!

GINT: I don't understand.

MISHA: I'm telling you, get out of here, get out of my home! You little Nazi runt!

GINT: Calm down!

MISHA: Get out!

GINT shrugs his shoulders and moves towards the door. He stops. He turns.

GINT: I'll say this to you, old man. You have never had a home here. And you never will. And nor will your

children, and nor will your grandchildren. Go back to your Russia! They'll kiss your arse for you over there! I'll even help you pack your suitcase and drive you to the station. Free of charge. Heil Hitler.

GINT exits into the hallway, slamming the door behind him.

UNCLE MISHA gets his rifle out of the cupboard, quickly removes its packaging and goes towards the door. He stops. He stands for a while in silence, then puts the gun back in the cupboard. He sits on his bed, in despair. He then takes out his suitcase, opens it.

SCENE 12

GINT stands in the hallway, checking his list in his notebook. BORIS climbs the stairs.

GINT: Hi. What are you doing here?

BORIS: Hi.

They shake hands.

One of my veterans lives here.

GINT: Yeah I just dropped in on him by mistake. Nice old bloke. *(Indicating the washed-off swastika.)* Did you paint that?

BORIS: I thought it was you.

GINT: I've got a veteran here as well. *(Points to the door to VALDIS' flat.)* Two, even.

BORIS: Haven't seen you in a while…

GINT: Oh… My wife's pregnant, my dad's broken his leg. I've a lot on basically. It's not a life, it's a struggle to get everything done. Listen, what printing company do you use?

BORIS: I can find out for you.

GINT: Do, and find out how much they charge. Ours have put the prices up.

BORIS: All right. I'll let you know tomorrow. You doing door-to-doors?

GINT: Yeah. Can I give you a lift anywhere?

BORIS: *(Points to the door to SASHA's flat.)* I need to drop in here too, gonna say hi to The Traitor. This guy said a lot of stupid things on TV yesterday…

GINT: I heard.

BORIS: Well I missed it. I was watching CNN.

GINT: Just don't kill him.

BORIS: I'm not going to. I'll hire you to do it.

GINT: Don't forget about the printers.

GINT goes down the stairs. BORIS rings MISHA's doorbell.

SCENE 13

UNCLE MISHA opens the door and BORIS enters his flat. There is an open suitcase, filled with things.

BORIS: Just dropping by, Uncle Misha. I wanted to look in on your neighbour. Did you see it?

MISHA: *(Putting things into the suitcase.)* I saw it.

BORIS: What are you going to say to him?

MISHA: I don't have anything to say any more.

BORIS: I don't know what they offered him, but they obviously bought him. The Latvians. It's useful for them to show the rest of Europe that Russians live normal lives here and think exactly as they do. It's all politics. No one would just stand up for the Nazis like that, not even in Germany. Is he a decent guy? I know his daughter…

MISHA: Anya?

BORIS: Yeah.

MISHA: I'm leaving you my keys, Boris. Give them to Anya later. Okay?

BORIS: Where are you going?

MISHA: I'm going to see my daughter. There.

He hands over the keys. BORIS takes them and puts them in his pocket.

BORIS: It's funny, I met him the day before yesterday. Do you know him well? Have you seen him today?

MISHA: I need to get going. My train's soon.

BORIS: Fine, I'll pass on the keys. *(Pointing to the wall, which adjoins SASHA's flat.)* What, are they not in at the moment?

MISHA: No questions, just pass on the keys.

BORIS leaves and rings on SASHA's doorbell. SVETA opens the door.

SCENE 14

BORIS and SVETA enter the room.

BORIS: Hello. *(To SVETA.)* My name's Boris. Your husband and I are already acquainted.

SVETA: Please, sit down.

BORIS: Thank you. *(Addressing himself to SASHA.)* Well, you're something of a celebrity. You're in all the papers. We were talking about you all morning.

SASHA: I can imagine what you were saying...

BORIS: No, no. We had your best interests at heart. We... *(He sits down.)* We understand... your point of view. We were thinking about how we could help you.

SASHA: I don't need your help. I'll get by on my own...

SVETA: Sasha! Listen to the man.

SASHA: I'm listening.

The sound of the front door. ANYA enters.

BORIS: *(To ANYA.)* Hi. I thought I'd pay your family a visit.

SVETA: *(To ANYA.)* How are you?

ANYA: Fine.

SVETA: Please go on, Boris.

ANYA stands in silence.

BORIS: You know, I was surprised when I saw you on television. I've known your daughter a while, now…

Everyone is silent, waiting for him to continue.

We know you're not a bad man, you've raised such a fantastic daughter.

SASHA: It's your party who's been raising her recently.

BORIS: That's not true. I understand… You really are a Russian: it's you against the world!

SVETA: He just wasn't thinking…

BORIS: Right! In our situation every word is worth its weight in gold. You haven't even had a chance to blink, and the Latvians are already using it to their advantage. Do you know whom I met just now outside your door? A nationalist! A Latvian nationalist! A Nazi dog!

SASHA: He was probably here to see Valdis.

BORIS: Or was he here to see you?

SASHA: The old man who lives to the right. A Legionary.

BORIS: *(To ANYA.)* Tough neighbourhood…

ANYA is silent.

SVETA: That's just this country.

BORIS: And we're trying to change this country.

SVETA: And who's against that?

BORIS: Your husband, for example. *(To SASHA.)* You could have used the word "Nazis" yesterday. And we wouldn't

be having this conversation today, and you wouldn't have a swastika on your door. And people in Russia would have seen that we have good reason to fight. And they would have helped us... On a political level, of course.

SASHA: I don't really want to fight.

BORIS: But we need to! And you need to even more than I do! You have children. Do you want them to be thought of as slaves in this country? Second-class citizens?

SASHA: Let them be fifth-class for all I care, people are people!

ANYA: Dad! My friends are too ashamed to look at me!

SASHA: *(To ANYA.)* Not now.

BORIS: You know, despite everything, I look at your daughter and it makes me believe. In a brighter future... I'm sorry, your fusspot Christian ideas... they're a dead end. We need to fight. Everyone needs to join together and fight. This morning with my colleagues...

SASHA: Do you want to paint a hammer and sickle on my door?

BORIS: I'm serious.

SVETA: Go on.

BORIS: In short... you could join our party.

SASHA: *(Laughing.)* Brilliant!

BORIS: It's not funny. Do you realise how much of a blow that would be to the Latvians? Better than any demonstration.

SASHA: It'd be a blow to me. They'll say that bloke's completely lost his mind.

BORIS: But they'll understand. It'll be like an epiphany. A man lives in ignorance, and suddenly he sees sense.

SASHA: How old are you, Boris?

BORIS: What difference does that make?

SASHA: None whatsoever.

BORIS: Just you think it over. Anya, do you have my number?

ANYA nods.

SASHA: And how much money do they give you for every new party member?

SVETA: What are you saying?!

BORIS: *(To SVETA.)* Don't worry. I'm not offended.

SASHA: Well I am.

BORIS: Something I said?

SASHA: *(Standing.)* Something you are.

BORIS also stands.

(Clenching his fists.) Get out!

BORIS: *(To SASHA.)* Goodbye.

SASHA: Don't you ever come back here again! You corrupted my daughter! And now you come into my house!

SVETA holds SASHA back. BORIS leaves. ANYA watches him go.

SASHA: It's him, *(Pointing to the door.)* it's him who wants you to be like this. And now he's even ready to take me into the party. Me, the traitor and the Nazi!

ANYA: If you repented…

SASHA: But I have no reason to repent, my girl. Because I'm right. Because until people forgive and forget there won't be any progress. Let's make everyone take separate trams, shall we? Red for Russians, blue for Latvians. Separate hospitals too: "Oh look, a Latvian's dying, call a Latvian doctor. What? They're all busy? What a shame, we'll just have to wait till one's free then." Oh what a wonderful life! Then we'll all start grabbing our assault rifles. And that'll be that. Blood on the streets!

(While this is going on, UNCLE MISHA leaves with his suitcase.)

ANYA: Oh is that why you've gone over to their side then? Because you're scared of blood? That's why you've betrayed your family and your people… To be a peacemaker. The Latvians don't want you and your preaching either. They'll just put you in a zoo: "Roll up, roll up ladies and gentlemen and see the volunteer Legionary!" People were saying to me today, "You're the Legionary's daughter!" And I'm ashamed to be your daughter!

SVETA: *(To ANYA.)* Stop it! How dare you speak to your father like that? You rotten little girl!

SASHA: She's not the problem, Sveta. There's a whole party of people who think like this. It's a production line.

ANYA: They're more of a family to me than you've ever been! And more honest! I'm not a rotten little girl! I…

SVETA: What? You what?

ANYA: I'm no longer your daughter!

SVETA: Okay then, let your precious party bring you up, let them find you a husband.

ANYA: That's exactly what I'll do!

SVETA: What do you mean that's exactly what you'll do?

ANYA: I don't need anyone to find me a husband. I'll fuck anyone I like! Boris! Or someone else! Anyone who wants to!

SVETA runs over to her daughter and strikes her hard across the face. SASHA puts his head in his hands. ANYA's face streams with tears.

I'm leaving this house!

SVETA: Shall I help you pack?

ANYA: I'll do it myself. Just know this: we'll get our way. And it was me who painted that swastika on our door! I wanted everyone to know!

SASHA: You?!

ANYA: *(Crying.)* I hate you! *(To her father.)* Nazi!

> *ANYA runs out of the room. The noise of the door, slamming loudly. SVETA looks out of the window. SASHA sits in silence.*

SCENE 15

VALDIS' flat. PAULIS is looking through the pamphlet left by GINT. VALDIS is next to him.

VALDIS: Put it down. It's exactly the same as the Soviet ones. The same people wrote them.

PAULIS: I'm just having a look.

VALDIS: Put it down, it's offensive. He thinks if he comes round once a year I'll vote for him.

PAULIS: At least he comes round in the first place.

VALDIS: When we die they'll just cross out our names in their notebooks and that'll be it. He doesn't need you, he needs your vote.

PAULIS: I understand, I'm not a child.

VALDIS: I sent him over to my neighbour's. He won't be able to say he's never shaken hands with a Russian now. Or never taken a thrashing from one either.

PAULIS: You're odd, Valdis, when it comes to all this.

VALDIS: No, I'm quite normal. As it happens, I can go to their parade on the ninth of May as well. I have a medal "for the victory over Germany".

PAULIS: You what?

VALDIS: Now don't you start clutching your chest again. I suppose you could say that I am the fate of the entire Latvian nation in one person.

PAULIS: I don't understand.

VALDIS: What, my dear, did you do before the War?

PAULIS: I was studying.

VALDIS: I was studying too. To be a driver. I joined our army in thirty-nine. The uniform was beautiful. When I got home any girl was mine… When the Russians arrived in forty they took our trucks off us, but they didn't have anyone to work on them.

PAULIS: Those Russians can't tell their spark plugs from their arseholes.

VALDIS: So they made me join the Red Army. I drove exactly the same route, taking provisions to the guardhouse. Of course the uniform was a bit worse but overall – no difference at all. Then the War started. I managed to make home to the farm, and hid my uniform. Except my boots. I kept wearing them, there was nothing written on them.

PAULIS: Russian boots are bloody terrible, I had to wear them in the camp…

VALDIS: They're decent boots. Then the Germans decided to form the Legion. Took one man from every family. And my brothers were both already married. First time I ran away from the drafting station. But they found me. I got another new uniform but my route was the same: to the guardhouse. And most importantly, the truck was the same. I was in luck. Third army, same truck. And when the Russians came back you can guess what happened.

PAULIS: They let you stay?

VALDIS: Of course. Me and my truck. And then they gave me a medal.

PAULIS: So when did they put you in the camp?

VALDIS: They didn't do that until forty-nine. And they shouldn't have put me there anyway. It was supposed to be the head of our motor-transport depot on the arrest warrant. But he switched my name for his. He's still alive, the old swine.

PAULIS: Is he Russian?

VALDIS: Latvian.

PAULIS: That old swine.

VALDIS: So, what, am I now supposed to hate all Latvians? Or all Russians? In the camp by the way, my best friend was Ukrainian.

PAULIS: And mine, I'm ashamed to say, was Russian. A thief.

VALDIS: Well?

PAULIS: Well fine, maybe that's different… But if they're living in my home they should respect me and they shouldn't litter. There are little bins outside every house…

VALDIS: That's got nothing to do with nationality.

PAULIS: Everything should go in the bin: My mother taught me that when I was a child. When I was five years old, I got in trouble for sweeping up all the chicken shit in my grandmother's yard and putting it in her post box. The postman got a nasty surprise the next morning.

VALDIS: You think the shit's still there now?

PAULIS: *(Laughing.)* Some Russians bought that farm off my uncle a while ago. I suppose they inherited the chicken shit too.

SCENE 16

ANYA and BORIS quietly climb the stairs and approach UNCLE MISHA's flat. BORIS gets out the keys, which jangle.

ANYA: *(In a whisper, pointing to the door to her flat.)* Quietly. Unless you want to go in for round two?

BORIS: No, I don't.

They enter UNCLE MISHA's flat and lock the door behind them.

ANYA: *(Softly.)* Uncle Misha!

BORIS: I'm telling you – he's gone. Why else would I have his keys?

ANYA: No. He wouldn't just leave.

They move further into the room. They turn on the light.

BORIS: You see?

ANYA: *(Calling.)* Uncle Misha!

ANYA starts walking around the flat, looking for UNCLE MISHA.

BORIS: Anya, he gave me his keys.

ANYA: He didn't even say goodbye.

BORIS: He was being a bit weird. Normally he just chats to me, asks me questions. But today he says "My train's soon." Where does his daughter live?

ANYA: Russia. *(Pause.)* Something's happened. He wouldn't leave just like that.

BORIS: Maybe it was because of what your father said.

ANYA: Don't bring that into it.

BORIS: Or maybe his daughter asked him to come. He'll be gone a while, then he'll be back. Let's go.

ANYA: *(Puts her hands on the table and leans on them, looking at the keys and starting to cry.)* He won't come back.

BORIS takes out a handkerchief. He gives it to ANYA. She wipes her tears.

BORIS: We can't allow ourselves to cry. You understand? Uncle Misha told me to give you his keys. He wanted you to have them.

ANYA: He's definitely not coming back.

ANYA starts crying again. BORIS goes over to ANYA. At first he strokes her hair, then embraces her, then kisses her cheek. His hands move down towards her stomach.

BORIS: Hey… There's no need to cry… Everything'll be fine…

BORIS starts to unbutton ANYA's blouse. She does not resist.

SCENE 17

SASHA's flat. SASHA and SVETA are in the main room. The television is on. They are silent. LYOSHA enters. His hands and his coat are covered in blood. LYOSHA removes his coat. SASHA picks up the coat. SASHA and SVETA remain silent.

LYOSHA: We need to hide this somewhere.

SVETA: Oh my God! What happened to you!?

LYOSHA: Nothing. Not so far, anyway.

SASHA: What happened?

LYOSHA: I think the police'll be here soon.

SVETA: Lyosha!

LYOSHA: It's just the way it turned out.

SASHA: Talk to us.

LYOSHA: Well… people read the newspapers. And every little bastard out there wants to express their opinion on it. And when two little bastards started expressing their opinions to me, I wasn't gonna put up with it.

SASHA: Are they still alive?

LYOSHA: Probably. But they squealed so loud that someone called the police.

SVETA: *(Clutching her head.)* What have you done?!

LYOSHA: No one talks about my father like that!!!

SASHA: Like what?

LYOSHA is silent. SVETA stands and takes him by the arm.

SVETA: Come on. Let's go and wash your hands. Sasha, put the coat down.

LYOSHA and SVETA leave. SASHA sits down, the bloody coat is laid out on his knees. SVETA re-enters and takes the coat from him.

SVETA: Look what you've done.

SVETA leaves. SASHA remains sitting, staring at the wall. Knocking at the door. SASHA stands. More knocking. SASHA answers the door. VALDIS and PAULIS enter.

PAULIS: I wanted to thank you for what you did yesterday. It was my heart. My age… In short, thank you very much.

SASHA: All we actually did was meet the paramedics.

PAULIS: But you met them, and I'm still here today... Pass on my thanks to your children.

SASHA looks at VALDIS. VALDIS is silent.

SASHA: Yes, definitely. Would you like some tea?

PAULIS: No, thank you. We've been drinking tea all day.

PAULIS nods and leaves. VALDIS after him.

SCENE 18

UNCLE MISHA's flat. BORIS is lying on the bed under the blankets. ANYA is already dressed. BORIS' clothes are strewn nearby on the floor.

ANYA: I've loved you for ages. I always wanted you to be my first. My only. I even know what colour blinds you have in your flat…

BORIS lightly caresses ANYA's head.

BORIS: What colour?

ANYA: I've only ever wanted to be with you.

BORIS: You see, you want something enough, you always get it in the end.

ANYA stands. She starts pacing around the room. BORIS watches her. ANYA stops.

ANYA: Do you want to stay here, live here together for the rest of our lives? Do you want to?

BORIS: Of course. We'll pop over and see your parents for tea.

ANYA: *(Stops.)* No we won't!

BORIS: Fine, we won't.

ANYA: You know, I'm ready for anything now. Absolutely anything. You understand? I love you.

BORIS: You're amazing…

ANYA: Tell me to kill, tell me to blow something up… I'll do it without a second's thought.

BORIS: Are you serious?

ANYA: You're all I have left.

BORIS: *(Starts to get dressed.)* I'd never tell you to do anything like that.

ANYA: Tell me! Tell me! Don't you see, what we're doing now, these meetings… They're not enough. We need to do something! I keep thinking I want to sit in Freedom Square and set fire to myself. Loads of revolutions have started like that.

BORIS: And you could do that, could you?

ANYA: Yes! Right now I'm sure I could! Then everyone would understand, the whole world. Even my father!

BORIS: Anya, there are other methods.

ANYA: They don't work.

BORIS: From now on I'm going to start hiding matches from you.

ANYA: Or we could shoot the president…

BORIS: What for?

ANYA: Because it's real!

BORIS: They'd put you in prison.

ANYA: They'd have to let us out sometime, wouldn't they?

BORIS: What do you mean, "us"?

ANYA: What, are you not with me?

BORIS: I'm with you, of course, but I don't think I'm quite up for setting fire to myself or shooting the president. You can use your situation to get yourself a post in the party. And then together we could... You're in a really strong position: your dad's a traitor. That will really help.

ANYA: What's this got to do with my father?

BORIS: Just trust me, I've been in politics a long time. If you set yourself up in opposition to him then you can use the fact he's betrayed you personally. Your views. And you'll be able to score lots of points in the party off that. And I'll back you up.

ANYA: I don't understand.

BORIS: It's better than shooting people.

ANYA: Better for who?

BORIS: For you, for me.

ANYA: And for people? For Russians?

BORIS: People go wherever you lead them. And either you're the leader or you're just part of the herd.

ANYA: People aren't sheep!

BORIS: Yes, of course, of course. People are the most important thing. We're doing all this for the people. But... *(Short pause.)* We're people too. Only we're a bit cleverer, a bit better than the rest.

ANYA: I don't understand.

BORIS: You don't understand? *(Pause.)* What isn't there to understand? We can't actually change anything: set fire to yourself, start shooting people... Demonstrate. It won't change anything at all! When you understand that, you'll be able to see everything more clearly. *(Pause.)* Everything in this country is decided by America, by Germany, England, Russia... It's just a game for us. And everyone's in it for the money. People are tools, and I use them, and

77

I suggest you do too. *(Pause.)* Fine. I'll explain again later. Come here.

ANYA: So you can strengthen your position? Was that bed over there also for strengthening your position? Or to get your own back on my father? Was that it?

BORIS: Anya!

ANYA: So it was some kind of political move?!

BORIS: Listen, Anya, you're just not thinking…

ANYA: And you've got it all thought out!

BORIS: You're putting yourself in danger, you and everyone around you.

ANYA: But we need that danger! Mister politician here is frightened of it! But I'm not scared! I'm not scared of anything any more! Do you want me to prove it? *(Pause.)* But what could I possibly prove to you? You know everything already. And your hands are always clean. The Russian party, the Latvian party: we're all the same to you. You don't care! Get out.

BORIS: Just calm down, then tomorrow we can…

ANYA: Tomorrow's too late.

BORIS: Anya, I understand everything you're feeling, but…

ANYA: Get out, Boris. Run back to your party.

BORIS shrugs his shoulders and goes. He stops.

BORIS: Can I call you, at least?

ANYA: What for? So you can fuck me again? Did you enjoy it?

BORIS: I did.

ANYA is silent. BORIS leaves. ANYA goes to the wardrobe and takes out the rifle and the bullets. She sits, and loads the gun. She walks out into the empty hallway. She stops in the middle, holding the rifle in both hands.

END